ISABELLA STEWART GARDNER

ISABELLA STEWART GARDNER

A LIFE

NATHANIEL SILVER
DIANA SEAVE GREENWALD

Isabella Stewart Gardner Museum, Boston
Distributed by Princeton University Press, Princeton and Oxford

CONTENTS

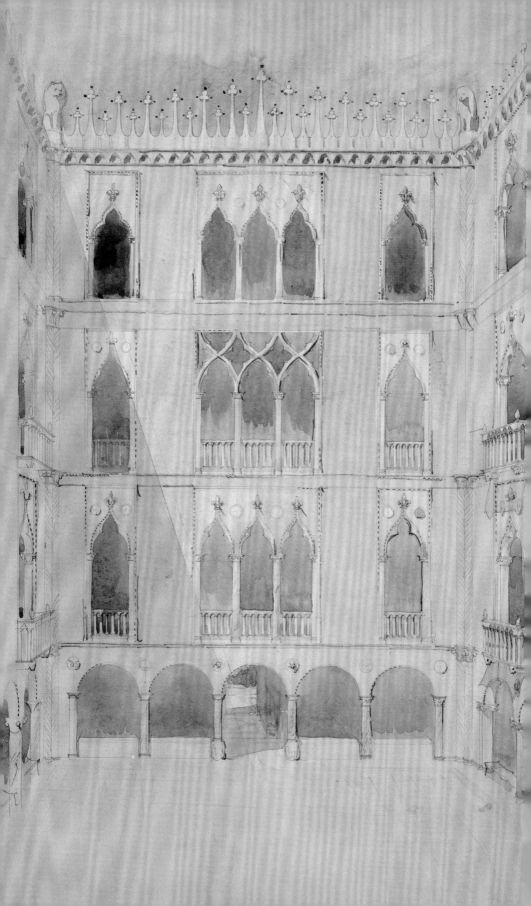

DIRECTOR'S FOREWORD

In 1925, one year after Isabella Stewart Gardner's death, this Museum published *Isabella Stewart Gardner and Fenway Court*. Its author, Morris Carter, the Museum's first director and a close friend to Isabella, worked with her, her friends, and family to "forever refute many of the legends current during her lifetime." Carter's highly personal and often anecdotal narrative is the first biography of our pioneering founder and, absent a more accurate resource, remained a cornerstone of the Museum's institutional history. Yet the legends persist. As we near the one hundredth anniversary of Isabella's death, a reassessment is long overdue. Our institution has evolved and so, too, have the perspectives of our visitors, who now number over three hundred thousand a year.

This book offers fresh perspectives, explores Isabella's identity, and situates our founder in the context of her time. It resonates with our institution's strategic goals and our commitment to explore complex histories and their relevance to our equally complex present. Our authors, curators Nathaniel Silver and Diana Seave Greenwald, confront the myths, update Gardner's story with new information, and respond to some of visitors' most frequently asked questions: Where did Isabella's money come from? Was she a feminist? Did she, her husband, or their families enslave people? With what resources did she create this institution and assemble such a fabulous collection? Many of these questions are as complicated as Gardner's own personality. This book provides only a glimpse of possible answers and leaves many lines of inquiry open—an unsurprising result for a subject like Isabella, who curated her image as carefully as her collection.

For their excellent work, I would like to thank Nat and Diana, who co-authored this timely text in the midst of a global pandemic, with reduced access to archival resources, and as both welcomed babies (Gus and Eloïse) into their respective families within two weeks of each other. For their generous support of this publication, we are extremely grateful to the Arthur F. and Alice E. Adams Charitable Foundation.

PEGGY FOGELMAN, NORMA JEAN CALDERWOOD DIRECTOR

ACKNOWLEDGMENTS

In many ways, this book was a century in the making. The Museum last published a life of Isabella Stewart Gardner in 1925—a volume written by the institution's first director, Morris Carter. When we began to discuss this project several years ago, everyone agreed that a new biography was long overdue. Thanks to the global pandemic, as well as several parental leaves, its genesis unfolded more slowly than originally planned. Now, nearly one hundred years since the death of our founder, we are proud to present this new introduction to her life.

First, we thank Peggy Fogelman, the Museum's Norma Jean Calderwood Director. Peggy not only provided the time and resources to produce it but also lent her expert eye to reading an early draft of the book and providing essential feedback. In the early stages of this project, our colleague Michelle Grohe helped us frame what this book should address for our visitors.

The actual research and writing drew on our colleagues' years of expertise. Shana McKenna helped us navigate the wealth of resources in the Archives and took on the titanic task of checking all of our footnotes. In addition, we were able to draw on our colleagues' contributions to our Museum blog, *Inside the Collection*, and the research they have compiled while digitizing our collection. Thank you to Kathleen King, Dakota Jackson, and Alex Eliopoulos, and to Nancy Berliner from the Museum of Fine Arts Boston, who served as our Consulting Curator of Chinese Art in 2020.

Elizabeth Reluga not only shared her deep knowledge of the collection but also was the driving force that kept this project on track. She navigated every supply chain obstacle, layout change, and impending deadline. We owe her a great debt of gratitude. She was ably assisted by Shanna Smith, photographers Amanda Guerra and Sean Dungan, and curatorial assistant Adrienne Chaparro. We are grateful to them all. Miko McGinty and Julia Ma designed this beautiful volume.

Finally, we thank our respective spouses, Caroline Fowler and Hugues Le Bras, for giving us the time, space, and support to write collaboratively during a pandemic and with new babies on the way. We dedicate this book to our boisterous newborns, Gus Silver and Eloïse Le Bras, two wonderful children delivered within weeks of each other last fall. Thank you again to Caro and Hugues for your remarkable patience—and to the two babies for sleeping through the night when it was truly crunch time.

NATHANIEL SILVER, WILLIAM AND LIA POORVU CURATOR OF THE COLLECTION AND DIVISION HEAD

DIANA SEAVE GREENWALD, ASSISTANT CURATOR OF THE COLLECTION

Isabella with Kitty Wink, Patty Boy, and Another Fox Terrier Friend on the Roof of Fenway Court, about 1900, from *Guest Book, Volume VI*, page 42

INTRODUCTION

Captivated by the paintings, sculptures, and tapestries, many visitors to the Isabella Stewart Gardner Museum overlook the simple glass cases that fill its ground floor rooms (fig. 1). They contain an unassuming collection: what seem to be little more than piles of paper and historic photographs. Nonetheless, each letter, manuscript, photograph, and clipping presented in these galleries is as much a part of the Museum's holdings as its treasures of fine art. The papers, which belonged to Isabella Stewart Gardner (1840–1924), the Museum's founder, represent her personal correspondence, as well as her collections of documents related to historical figures she admired. Some are arranged into thematic groupings, such as "Presidents and Statesmen" and "French Authors," while others are displayed in cases dedicated to her closest friends and advisors, including art connoisseur Bernard Berenson and Japanese scholar Okakura Kakuzō.

Gardner kept very little of her own writing—in fact, she had some of it destroyed—but the contents of the cases say as much about her as about the various other figures they illuminate. The papers Gardner preserved reflect her friendships, allegiances, and alignments with artists, writers, musicians, scholars, poets, and other personalities of her day, as well as with notables of the past. She curated these relationships—real and imaginary—as carefully as she did the masterpieces she acquired for her Museum. In addition, she gathered hundreds of newspaper clippings

about herself, tracing a public image often shaped by speculation and even featuring images of women who clearly were not her (fig. 2).

Gardner delighted in the splashiest articles. Whether verifiable truth, outright lie, or a mixture of fiction and fact, they dramatized the ways in which her life fell outside the boundaries of contemporary expectation (maybe this is why she collected them). In one instance— her outings in the late 1890s to Boston's zoo, where she was granted the privilege of walking the wild animals, including a lion named Rex— she assembled no fewer than four reports from the press. The one that ran in the *Boston Sunday Post* was titled "Mrs. Jack's Latest Lion: The Society Leader Chooses, Not a Man This Time, but a Real King of Beasts" and recounts:

> On Monday last Mrs. [Jack] Gardner extended her special atten-
> tion to a fine young lion, called Rex. . . . She sauntered about . . .
> with an immense yellow-eyed lion by her side, her hand rest-
> ing on his neck and he swinging along as contentedly as though
> he had been under Mrs. Jack's care every day of his life. Surprise

FIG. 1 The Crawford/Chapman Case in the Blue Room

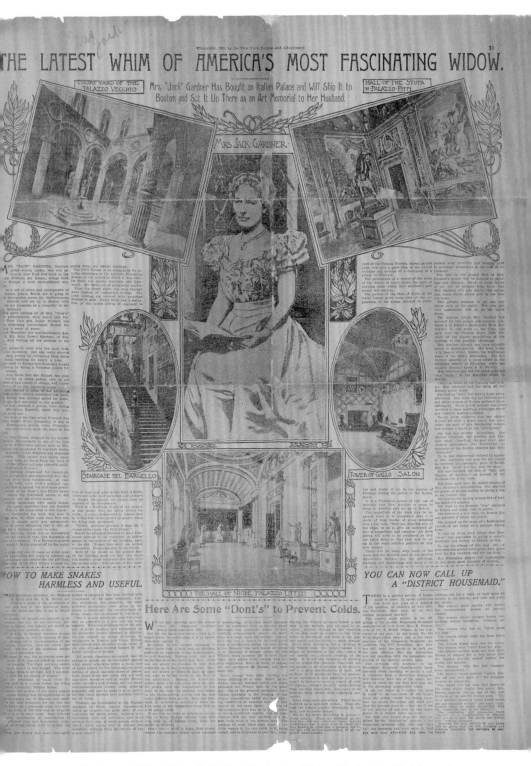

FIG. 2 "The Latest Whim of America's Most Fascinating Widow," in the *New York Journal and Advertiser*, 17 December 1899, with a photograph (center) of an unknown woman

MRS. JACK'S LATEST LION

The Society Leader Chooses, Not a Man This Time, but a Real King of Beasts.

Mrs. Jack Gardner, whose penchant for the so-called "lions" of the human race has made itself manifest at odd times and in odd manners in the past, is now turning her attention to the four-footed members of the carnivorous family of that name.

Everyone who has any knowledge of Mrs. "Jack" knows without the telling that she is eccentric, and that she delights in setting the swell circles in which she is a leader to talking over some abrupt departure from the humdrum of everyday society life. Although she is Boston's Mrs. Jack Gardner, she is equally at home in New York and Chicago and no big, gilt-edged event in either of the three cities is regarded as quite complete unless graced by her presence and enlivening influence.

Just what has turned Mrs. Gardner's fancy to the king of beasts does not appear. It may be that even the most distinguished lords of creation prove an acquaintance to be only of ordinary mortal clay, and that the office of entertaining and encouraging them has become monotonous. This is a question that only the lady herself can solve, and she is not given to disclosing the motives that move her. But she does not attempt to disguise her liking for taming coated lions of the real king, and as it in ways that few men, to say nothing of the gentler sex, would dare to do. Just how far Mrs. Jack will have the courage to go in cultivating Leo's friendship cannot be conjectured, but there are those who say no surprise need be felt if in the near future she has the handsomest specimen of a Nubian lion money can buy, frolicking through her splendid house on Commonwealth avenue, just as average folks give a pet cat the run of the parlor.

MRS. GARDNER AT THE ZOO.

So far Mrs. Gardner's new passion has found an avenue of expression at the Zoo in the old Public Library building. When that institution opened early in the winter she was among the first to inspect its collections of all that goes to make such complete and interesting. One of the baby lions was especially admired, and in a quiet way patted and petted through the bars of the mother's cage. Then Mrs. Jack became an almost daily caller, the liking for the baby lions gradually extending to the dozen or more of all ages and sizes first. With some of them a real friendship resulted, and her coming began to be looked for by them with every manifestation of pleasure. One day Mrs. Jack wanted to take the two baby lions home. It did not seem within the range of possibilities at first, but when a woman's will and wit are combined, especially when that woman is Mrs. Jack Gardner, there are but few objections but what can be surmounted, and the two youngsters went in her carriage to Commonwealth avenue. The sensation created in the Gardner residence was a sublime one. No visitors were ever more warmly welcomed or carefully looked after. For an hour Jack gave herself with all her heart to the happiness of entertaining the pretty pair of cubs, and the parting was with reluctance on both sides. Since then Mrs. Gardner has watched the growth of the "babies" with increased interest, and many an extra tid-bit they and their mother have had is due to Mrs. Jack's solicitude for their welfare.

LED REX BY THE MANE.

On Monday last Mrs. Gardner extended her special attention to a fine young lion, called Rex. He is nearly three years old, about the size of a large mastiff and with every promise of being a magnificent specimen of his kind. He is a new comer, and Mrs. Gardner had been putting in a claim for his notice and good will for several days. At the time of her Monday call she took a sudden notion that she wanted Rex as a companion in a promenade about the building. Knowing him to be thoroughly tamed and fully to be trusted, Manager Bostwick consented, and Mrs. Jack had the felicity of doing what no other woman in the wide, wide world has ever done. She sauntered about old Bates Hall with an immense yellow-eyed lion by her side, her hand resting on his neck and he swinging along as contentedly as though he had been under Mrs. Jack's care every day of his life.

Surprise reigned among the spectators present. It is not every day that a woman in fashionable dress is seen under such conditions. The way before the two was quickly cleared, and no one ventured to dispute Mrs. Jack's right of possession to her new protege. The walk over, Rex was led back to his cage, while Mrs. Gardner took her carriage for home.

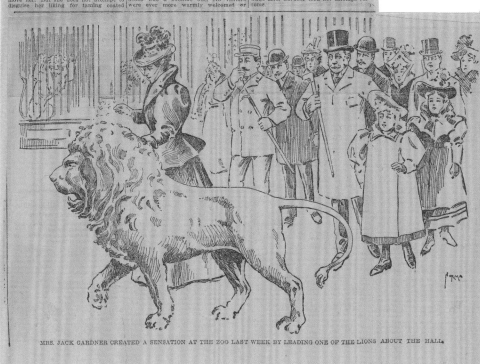

MRS. JACK GARDNER CREATED A SENSATION AT THE ZOO LAST WEEK BY LEADING ONE OF THE LIONS ABOUT THE HALL.

FIG. 3 "Mrs. Jack's Latest Lion," in the *Boston Sunday Post* (active Boston, 1831–1956), 31 January 1897

reigned among the spectators present. It is not every day
that a woman in fashionable dress is seen under such condi-
tions. The way before the two was quickly cleared, and no one
ventured to dispute Mrs. Jack's right of possession to her
new protégé. The walk over, Rex was led back to his cage, while
Mrs. Gardner took her carriage for home.

A full-size illustration accompanied the article (fig. 3). In it, a gaggle
of well-dressed spectators cluster nearby, staring agog.

Isabella Stewart Gardner was the consummate show person. Her
legendary outing with a lion, the way it was reported in the popular
press, and the fact that she collected articles documenting this exploit
but left behind no first-hand account of the experience provide a suc-
cinct introduction to the complexities of writing her biography. First,
while Gardner deliberately cultivated her outward image, few written
records of her deliberations and decisions survive. Mostly what remain
are her actions and quoted speech. Second, the public persona she cre-
ated, in comparison to that she presented to close friends, heightened
certain aspects of her interests and personality—often the more outra-
geous ones. The subject of stories ranging from taking jiu-jitsu lessons
to wearing Red Sox gear to the Boston Symphony, she seems to have
courted controversy and reveled in the waves of press coverage it stimu-
lated. Nonetheless, this showmanship masked what we know was a
fierce loyalty to and love for friends and family. She was a dedicated
aunt to her three nephews, who lost both of their parents at a young
age. Particularly after the death of their father—her husband's brother
Joseph, who had outlived his wife—she threw herself into their educa-
tion and care and raised them as her own.

The public flamboyance also masked private sensitivity and an
empathy for those in need. However, these qualities are sometimes hard
to capture because the first-person written record is so spare. While
she carefully collected news clippings about herself and preserved them
within her Museum, Gardner simultaneously erased records of her own
reactions to her life experiences—from the daring, like walking Rex,
to the tragic, including the death of her only child—and to the import-
ant political and social events of the day. She asked her friends to burn
her letters, leaving to posterity few of her own thoughts—although her
lengthy correspondence with her art advisor Berenson is a notable
exception. Instead, she shaped her image through the careful curation of
second-hand accounts. In addition, some of her own writings were
apparently too precious for her to discard: these include two travel dia-
ries assembled during trips abroad, a handful of inventories and lists of

works to be included in select spaces within the Museum, as well as a notebook from her first art history studies in 1883.

To see the world through Isabella's eyes, we rely on the copious visual evidence she left behind: her photographic travel albums, the Museum, and its collection. These are key sources for understanding her, though many mysteries remain. The scant written record of Gardner's thoughts and opinions provides just enough information to be tantalizing, yet not nearly enough to counter the rumor and guesswork consecrated in the earliest biographical accounts. Penned by Morris Carter—the Museum's first director, who had served as Gardner's secretary—and Louise Hall Tharp, they are, respectively, a hagiography and a gossipy critique. Most importantly, each book is a product of its time, Carter's published in 1925 and Tharp's in 1965, with little scholarly apparatus. Just as Gardner's idiosyncratic museum installations seem carefully designed to invite conjecture but remain stubbornly enigmatic, so too does her historical record.

The headline that appeared in the *Boston Sunday Post* about Rex the lion already hints at some of the problems endemic to the public sources, including Gardner's previous biographies, most recently *The Art of Scandal* (1998). They all persistently refer to her as "Mrs. Jack," adopting her husband John Lowell Gardner Jr.'s nickname. In her own lifetime, despite being a larger-than-life personality who courted publicity, Gardner was often referred to by this moniker and publicly defined in relation to her husband. While Jack himself was rarely mentioned in accounts of Isabella's exploits, he remained omnipresent, and reactions to her were typically framed in reference to her relationships with men. The subheading of the *Post* article alludes to this fact: "The Society Leader Chooses, Not a Man This Time, but a Real King of Beasts."

Born and wed into a hidebound upper class, within a deeply patriarchal society, Gardner frequently refused to conform to the norms of her gender and rank. Thanks in part to her wealth and determination, she was often able to push back against social expectations and became a subject of criticism in the popular press. Well into her advanced years, gossip columns were peppered with reports of her dancing and flirting with a range of men. Sometimes, it was implied, these interactions went beyond harmless fun and became full-blown affairs that violated Victorian notions of proper womanhood. The newspapers created the impression that Gardner was a frivolous woman; some even suggested she courted a degree of masculine attention not merited by her short stature, looks, and (later) age. In all of this, her husband fades into the background, relegated to funding his wife's whimsy—including her expensive art collecting habit. The secondary literature on Gardner

adopted the tone and tenor of these early accounts, perpetuating their implicit (and explicit) biases. As a result, a shadow of girlish frivolity and eccentricity (a word frequently found in the sources) lingers over studies of the Museum and its founder, minimizing her agency, contributions, and complexity as a historical figure and pioneering civic leader. The present biography provides a corrective introduction to Gardner's life, based on the best historical resources currently available—private accounts and documents, the contemporaneous public record, and the Isabella Stewart Gardner Museum itself.

In updating our understanding of Gardner, it would be easy to go for a radical course correction and present her as a straightforward feminist and iconic female museum founder. That would, however, be misleading. Instead, this book seeks to introduce her life in all of its complexity, from passion to prejudice. It considers, for example, the origins of Gardner's wealth, whether her family owned enslaved people, and if her or her husband's family profited from trade with regimes of enslavement. It embraces the historical interpretation refracted in the many images and accounts of Gardner across the century since she passed away in 1924. In this new biography, we accept the ambiguity and frequent inconsistencies in her opinions and intent. Gardner, like all people past and present, often behaved in contradictory ways. She harbored many biases—racial, ethnic, and social—all decidedly out of step with our twenty-first-century sensibilities. She was also, simultaneously, a pioneering collector, a brilliant curator, a social reformer, and a visionary institution builder who created a Museum that awed visitors in her lifetime and continues to resonate with today's public, more than a hundred years after it was founded. This biography does not seek to resolve the paradoxes in her persona, opinions, and behavior but to enrich our understanding of her remarkable life by revealing them.

Our book follows a roughly chronological path and draws both on well-known sources about Gardner's life and on a wealth of previously uncatalogued and unpublished sources in the Museum's own archives. Many of the questions we seek to address emerge from our present-day visitors. How were Isabella and Jack able to fund the creation of this exceptional place? Was she a political progressive ahead of her time, or a conservative elitist? Why was the Museum arranged in such a particular way, and why are there no labels identifying the works of art? This book is not the last say on Isabella Stewart Gardner and her legacy. Rather, addressing these questions is just the beginning of a conversation about an accomplished woman who, for all her notoriety, remains a puzzling figure deserving of re-examination.

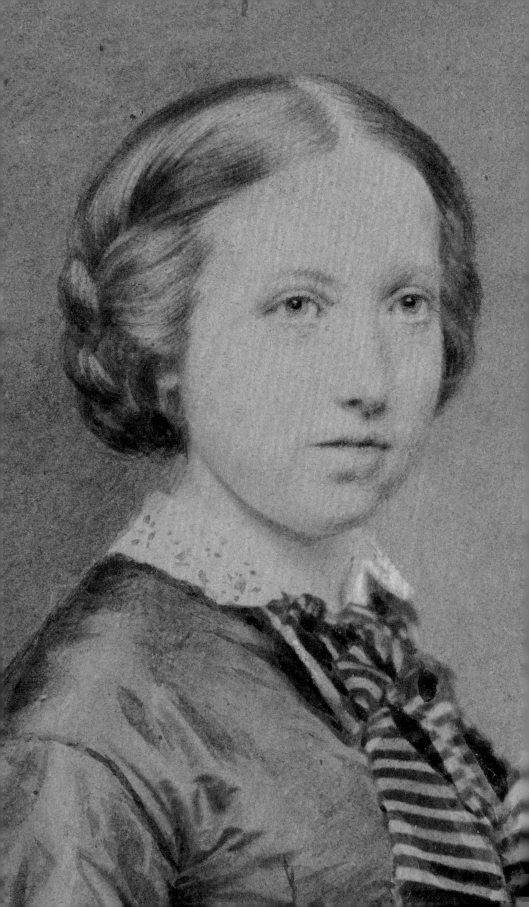

ISABELLA'S FAMILY
AND EARLY LIFE
1840–1867

Isabella Stewart Gardner collected lace—often exquisite examples made in Italy that feature elaborate patterns. Among these elegant pieces, one item stands out: a tattered fragment of sixteenth-century Belgian needle and bobbin lace that is said to have belonged to Mary, Queen of Scots. Gardner claimed descent from this legendary monarch via her Stewart heritage, and objects connected to this purported relationship are preserved in the Museum in the "Mary Queen of Scots Case" (fig. 4). They range from certificates issued by associations dedicated to the Stuart monarchs (the different spelling did not diminish Isabella's assertion) to fragments from the Scottish queen's bed hangings. According to Morris Carter, the only biographer who knew Gardner personally, "On Christmas Eve, when mass was celebrated in Mrs. Gardner's private chapel at Fenway Court [the Gardner Museum], it sometimes seemed as if her costume had been influenced by her favorite portrait of Mary Stuart."

Despite the conviction of Gardner's belief, her family was not descended from royalty—although it was certainly Scottish, by way of New York City. Gardner was born in New York on April 14, 1840. She was the eldest of four children and the only to survive past the age of twenty-six; her siblings were Adelia (1842–1854), David Jr. (1848–1874), and James (1858–1881). We can trace her family tree back several generations, with firm information available about the identities of her

grandparents and great-grandparents. Isabella's mother, Adelia Smith Stewart (1814–1886), was born in the village of Jamaica, on Long Island—now part of the New York City borough of Queens. Her parents (and therefore Isabella's grandparents) were Selah Strong Smith (1777–1818) and Anna Carpenter (1773–1828), both from the New York City area, but who passed away before Isabella was born.

Probate records offer a limited glimpse into the lives of Selah and Anna. The family lived in Brooklyn. Selah died intestate in his early forties, in 1818, and his land in Brooklyn was sold to cover debts. In her biography of Gardner, Louise Hall Tharp claims that Selah was a tavern owner. Whether or not this is true remains unclear, but his wife was the daughter of an innkeeper in the New York area. Tharp also claims that Selah enslaved a Black man who worked in his tavern, and that this man was sold when the estate was settled. Census records list one enslaved person in the Smith household in 1800 and two in 1810. The evidence from the census records ends there: we do not currently know any more about the identity of the enslaved persons, the work they performed for the Smiths, or if they were sold to cover any outstanding debts at the

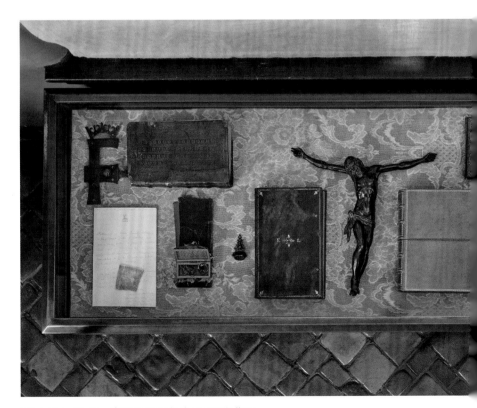

FIG. 4 Mary Queen of Scots Case in the Long Gallery

time of Selah's death. However, no enslaved persons were listed in the household in the following census (1820), and slavery was abolished in New York State on July 4, 1827.

Adelia Smith was only four years old when her father passed away, and a young adolescent when she lost her mother. The family's sources of income are unclear, but it seems unlikely that Adelia was exceptionally well-off. She married David Stewart (1810–1891), from a modestly prosperous family, in Brooklyn on May 2, 1839, when she was twenty-five years old. Isabella was most proud of this side of the family, which fueled her claims of royal descent. David was the eldest son of a Scottish immigrant, James Stewart (1778–1813), a dry goods merchant, and Isabella Tod (sometimes spelled Todd) Stewart (1778–1848).

Of all her relatives, Isabella showed the clearest affinity for her paternal grandmother. A graceful image of the elder Isabella (fig. 5) by Thomas Sully, an American portraitist famous for having painted Queen Victoria, hangs in the Gardner Museum's Short Gallery, opposite Isabella's own portrait. Recollections about Isabella's relationship with her namesake are preserved in the earlier biographies, notably the one

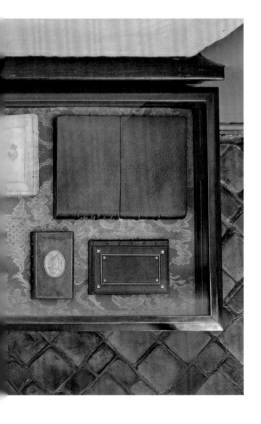

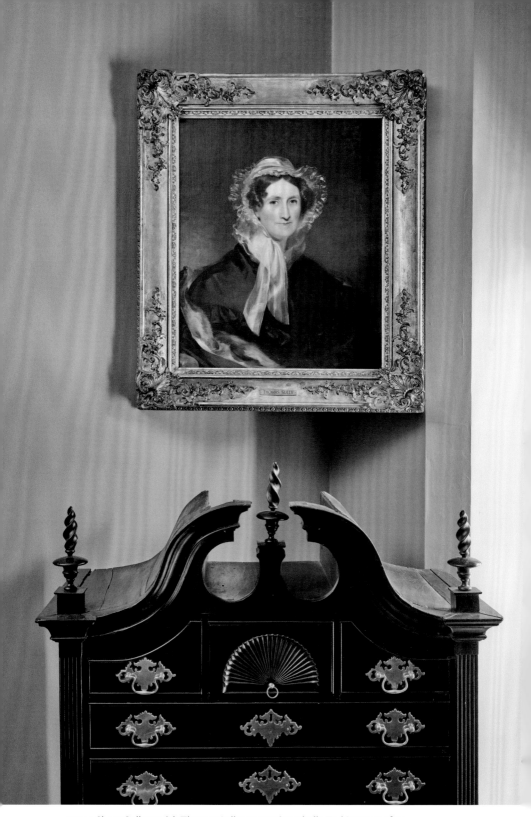

FIG. 5 Short Gallery with Thomas Sully's portrait *Isabella Tod Stewart*, 1837

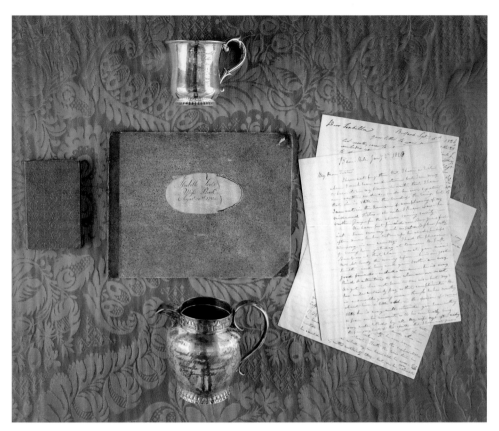

FIG. 6 Belongings of Isabella Stewart Gardner's grandmother, Isabella Tod Stewart, including a family Bible, her music book, collected correspondence, and silver awards from the Agricultural Society of New York

by Carter: she clearly loved her grandmother. As he writes, "The long summers spent on her grandmother's Long Island farm were periods of great happiness, never to be forgotten." The prominent display of the portrait by Sully and the fact that she kept many of her grandmother's possessions—such as a music book and letters she received (fig. 6)— also demonstrate the two women's affection.

Isabella Tod was born into a distinguished Connecticut family that had arrived in New England before the Revolutionary War. She was the daughter of David Tod, a "wealthy entrepreneur with interests in the mills" in Suffield, Connecticut. Tod built a large home for his growing family that still stands on Suffield's Main Street. He profited from enslaved labor, owning four people. A typescript of a chapter from a Tod family history compiled by another descendant includes the transcription of a letter in which Isabella's grandmother refers to a person named Nancy saying "Master's come! Master's come!" when one of the grandmother's brothers arrived home after a long absence. Census records confirm that the family enslaved people.

The elder Isabella and James married in 1805. The marriage was relatively short lived, as James died in 1813 when both he and his wife were only in their thirties. Newly responsible for her own family and business affairs, Isabella left New York City for the then-rural community of Jamaica, on Long Island. She successfully managed a farm there and became a savvy real estate investor—all more than a century before women could vote. Three silver vessels (a pitcher, a teapot, and a "tea mug") presented by the Agricultural Society of New York attest to her accomplishments as a farmer (fig. 7).

In his biography of Gardner, Carter writes that the work on Isabella Tod Stewart's Jamaica farm "was done by slaves" and describes them with racial slurs. But census records refute Carter's claim, showing no evidence Isabella Tod Stewart enslaved people. However, "two free colored persons" lived with her in 1840. Whether Carter's mischaracterization of Black workers as enslaved and his racist terms for them reflect his own biases or how Gardner—with whom he spent copious time—described her grandmother's farm is unclear. What is nonetheless certain is that, even though the two Isabellas only knew each other for about eight years, the elder made a formidable impression on her young granddaughter.

Given this strong connection, it is odd that the person who formed the direct link between Isabella Tod Stewart and Isabella Stewart Gardner—the latter's father, David Stewart—barely emerges in the Gardner Museum collection. Perhaps the younger Isabella was interested in highlighting a legacy of strong women in her family. In any case, the only image of him is a watercolor-enhanced photograph (fig. 8) tucked away in the Vatichino, a small gallery space that served as both personal treasure trove and closet. It shows a dapper, mustachioed man posing with a cane in front of a formal curtain and reveals that Isabella closely resembled her father. Despite the clear physical similarities, they do not seem to have been emotionally close. Carter noted, "Mrs. Gardner talked little about her childhood and her family. She admired her father, was loyal to her mother, and loved her brother."

Born into a modestly well-off family, David Stewart built the family fortune. Before the age of seventeen, he worked for a dry goods importer, Russell & Company. Several years later, he formed a partnership with a man named Thomas Patton, and together they founded Stewart & Patton, a firm that imported Scottish and Irish linens. It made Stewart wealthy. At the time, the term "linen" was applied not only to materials made of flax but also those woven from cotton. Stewart & Patton's textiles were possibly made from cotton farmed by enslaved people in the American South and shipped to Scotland and Ireland to

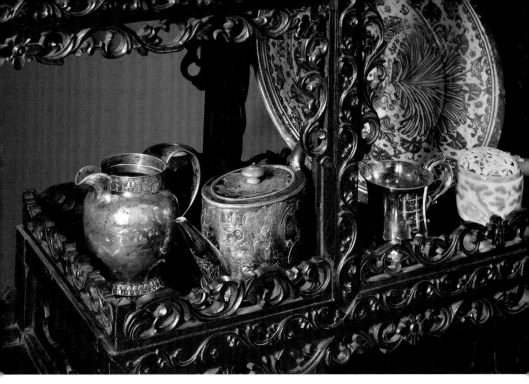

FIG. 7 Silver awards presented to Isabella Tod Stewart by the Agricultural Society of New York, displayed in the Short Gallery

be woven into fabric. Finished cotton textiles arriving in New York City were possibly destined for sale in states and countries with slave regimes, as clothing for enslaved people.

But it was a subsequent business decision that significantly enhanced the Stewart family wealth. Around the time of the Civil War, and perhaps because of the business's links to the South, Stewart began to move away from textile importing and diversified his business interests with investments in banking as well as coal and iron mining. In this he was assisted by first cousin David Tod (Tod's father, George, served in the Ohio State Senate and as an Ohio Supreme Court judge; he owned various mines and was governor of Ohio for two years during the Civil War). The Stewart family's transition from mercantile activities to investments in the large-scale industrial enterprises emerging in the day proved extremely profitable and was key to developing the family's fortune. When he died in 1891, David Stewart was president of the American Coal Company and a member of several elite New York organizations, including Grace Church and the Knickerbocker Club.

Stewart was survived by his daughter, Isabella, and his second wife, Mary Elizabeth Hicks Peck (1837–1916). He had married her in 1887, just one year after Isabella's mother, Adelia, passed away. Mary was only three years older than Isabella, had been married previously, and was also her cousin by marriage: Mary's mother, Mary Ann Smith Hicks

(1806–1877), was Adelia Smith Stewart's sister. This uncomfortable overlap of family relationships may explain David Stewart's conspicuous absence in the Museum and Isabella's records. While we know very little about her, Mary must have been a fascinating person; after Stewart's death she went on to marry for a third time, in 1894, wedding the famed Hudson River School painter Albert Bierstadt, best known for his monumental landscape paintings.

Upon his death, Isabella inherited significant wealth from her father. Carter states that she received $2.75 million, or about $78 million in today's dollars. Much of the fortune consisted of securities, recorded in surviving ledgers and revealing a fortune heavily invested in railroads, new utility companies, and mining interests. This Stewart wealth was the foundation of the funds she used to build her collection and Museum.

Isabella's fortune was relatively new—principally created by her father's business interests. She also married into "old" money. John Lowell Gardner Jr. (1837–1898) was the scion of a family that had been building wealth for generations. He was a Boston Brahmin—meaning "supreme self" in Hindi—the traditional term for the most elite Bostonian upper class, which could trace its lineage to a handful of founding families in Massachusetts. Jack, as he was known, descended from several of these notable families, although most directly from the Gardners and the Peabodys, merchants engaged in international trade and shipping.

Joseph Peabody, Jack's maternal grandfather, first made a fortune importing goods from the Dutch East Indies. During the first half of the eighteenth century, he traded primarily in Sumatran peppercorns. The spice trade was part of a web of merchant activity that underpinned Dutch colonial enterprises in Indonesia and was integrated into global trade networks that also engaged the British. Peabody, at some points in his career, also engaged in the opium trade in China. The scale of the family's wealth expanded further with the alliance forged through Jack's parents' marriage, which united the Peabodys to the Gardners. Both families were active in the East Indies trade through the first half of the nineteenth century, so the bond was advantageous from a business perspective—at that time economic ties could be solidified by family ones.

Part of the Gardners' wealth can also be traced to the Caribbean trade of the period. To date, no evidence indicates that any of Jack's direct ancestors enslaved people or traded in enslaved people, but they transacted business with slave regimes and imported commodities produced by enslaved labor. Before relocating to Boston in the 1790s, Jack's

FIG. 8 Portraits of Isabella's parents, David and Adelia Stewart, in the Vatichino

paternal great-grandfather operated a merchant house in Charleston, South Carolina, which traded in the Caribbean, and connections with the islands persisted after the family's move to Massachusetts. A letter written by Josiah Blakely, a U.S. consul in Cuba—then a slave regime under Spanish control—to Samuel Gardner, Jack's paternal grandfather, states, "Should you, or any of your friends, wish to try this market, the enclosed memorandum will direct you in selecting a cargo. . . . The sugar here is pretty good, the molasses equal to the best from St. Domingo." The Gardners continued to trade with Cuba into the nineteenth century. In 1831–32, Mary Gardner Lowell, Jack's paternal aunt, visited American-owned Cuban *ingenios* (sugar mills) and *cafetales* (coffee plantations) and assiduously documented how these slave enterprises functioned. She described enslaved people working with the scalding hot syrup in the dangerous sugar refining process—but she remained silent on the institution of slavery.

As the nineteenth century progressed, the Gardners diversified their economic activities and investments. Just as David Stewart transitioned from mercantile work to financing new industries, the Gardners did the same—but with a level of wealth that eclipsed Isabella's family's resources. John Lowell Gardner Sr. invested in real estate, securities, and local industry in New England. His son, Isabella's husband, continued this strategy. Jack invested his inherited wealth and the family resources he controlled in mining, railroads, and large-scale industry across the United States and internationally.

Jack's investments heralded the beginning of what historians call the Gilded Age, a moment of accelerating economic inequality when those able to deploy capital in the industrializing economy developed enormous fortunes. Both Jack Gardner and Isabella Stewart benefited from existing wealth that grew even larger. Newer money—like that of the Stewarts—increased swiftly, providing access to resources and experiences that had previously been the domain of long-established families, like the Gardners. This is how and why Isabella Stewart, of a nouveau riche New York family, could marry Jack Gardner, of impeccable Brahmin credentials.

An elite education was one of the experiences now accessible to individuals with "new" money. A series of certificates of excellence from a school run by Mary Okill, in New York City, and an autograph book that Gardner maintained throughout her adolescence and early adulthood attest to her schooling. The book includes copied poems, scraps of papers, and a wide range of praising notes from friends recorded between 1854 and 1861 (fig. 9). In 1856, David and Adelia Stewart arranged for Isabella—their eldest and at that point only surviving daughter—to attend a finishing

school in Paris, where she learned to speak the fluent French that she would maintain throughout her life. Her autograph book records traces of the interactions that would change Isabella's life. One of her classmates was Jack's sister Julia Gardner (1841–1921), probably through whom she met one of his other sisters, Eliza (1846–1898). The latter signed the autograph book: "Souvien [*sic*] toi de ta petite Amie, 30 Mar 1857" (Remember your dear little friend). It seems the Stewart and Gardner parents also met in Paris, as both couples accompanied their daughters during their European studies and then on tours around the continent.

After spending time in Paris, the Stewarts took Isabella to Rome, Milan, and Venice. She learned Italian, a language that would serve her well in later life as an avid collector and indefatigable traveler (by adulthood, she also spoke Spanish, according to contemporary reports). The families also overlapped in Rome, and that is where Jack and Isabella's paths first crossed—although the interaction seems to have left little impression on the young man. Writing to his brother George, Jack reported: "The Stewarts and the Waterstons we saw at Rome, as well as here." He seems to have been attracted initially to the Waterstons' daughter, Helen, saying she has "grown into a very tall, handsome and stylish young lady and is a very nice girl." Helen, however, became ill

FIG. 10 Joseph Gardner's poem "To Bella," 13 December 1858, in Isabella Stewart Gardner's *Autograph Album*, 1854–1861

"from the effects of an ascent of Vesuvius" and would later die from malaria contracted on her trip to Naples. The eighteen-year-old Isabella's reactions to her first European sojourn remain elusive, apart from the acquisition of what may be the debut book in her personal library: a volume of poetry, *Childe Harold's Pilgrimage* by Lord Byron, inscribed "14 April 1858, Rome." She did not return to Europe until 1867, nearly a decade and many life experiences later.

Back in the States, Isabella left a much stronger impression on Jack. In the winter of 1858–59, she traveled from New York to visit her friend from Paris, Julia Gardner. Julia wrote to her father on February 14, 1859:

> I have been enjoying extremely Belle's visit here, and I think she has also, for we have been very gay, although a great deal of our enjoyment was in a quiet way, small tea-parties, etc. The other day we had a delightful excursion out to Mrs. Forbes's in Milton. The sleigh, Cleopatra's Barge, called for us at about seven o'clock, and we drove out of town in company with some twenty other young people, all well "bundled up," and all in excellent spirits. Aunt Helen is kind enough to give a party to-night for Belle.

Another record of the trip—and the positive impression that Isabella made on the Gardner siblings—survives in her autograph album. Jack's eldest brother, Joseph, wrote: "May your own path in life be always strewn with flowers as gay as those which spring up everywhere around you under the vivifying influence of your sunny glance" (fig. 10).

Jack was smitten with Isabella. Tall and mustachioed, the eligible twenty-one-year-old bachelor had joined the family enterprises after only a couple of years of study at Harvard (fig. 11). Descended from several generations of notable Massachusetts families, he likely expected to marry a Boston girl from a similar background, as his brothers Joseph and George had. Instead, he defied expectations. The details of Jack and Isabella's courtship are not well documented—although this has not prevented endless conjecture as to its trajectory, including snowy winter walks on the Boston Common. But we do know that the courtship was quick. They were engaged by the end of February 1859, some ten weeks after the visit described in Julia Gardner's letter.

Jack and Isabella were enthusiastic about their engagement. Isabella wrote to her future sister-in-law, Julia: "Surely no one has so many causes to rejoice as myself; independent of the great event, the very kind letters and expressions of satisfaction that I have received from your family make me feel most deeply sensible of the happiness that is my lot." For his part, Jack wrote to his brother George: "To use your expression, 'I've gone and done it.' You probably are not surprised. The young lady has appeared charming since I have been here, and I am confident you will soon learn to love her not only on my account but her own."

John Lowell Gardner Jr. and Isabella Stewart married in New York City. The wedding was at Grace Church—where Isabella and her family were parishioners—on April 10, 1860, just days before the bride's

FIG. 11 John Lowell Gardner Jr., about 1860

twentieth birthday. She was now legally (and colloquially) "Mrs. Jack," a nickname that would follow her for the rest of her life. The couple honeymooned in Washington, D.C., and returned "as happy as possible," according to a letter written by Jack's sister Julia. They moved to Boston and began their married life together, making plans for establishing a home in the expensive new Back Bay neighborhood, where Isabella's father had purchased a tract of land for the young couple. A set of notes in Jack's diary records plans and furniture lists for their newly built residence at 152 Beacon Street (fig. 12). Setting up a home was not, for Jack, his wife's job alone. This was a sign of future collaboration, when the couple would turn their attention years later to art collecting and museum building.

Isabella, at only twenty, started her life in Boston as a vibrant newcomer in a conservative and hidebound social milieu dominated by old local families. Existing accounts suggest she struggled to adapt to the social life. Part of her difficulty may have been related to her and Jack's inability to have children. Evidence of the couple's experience with

FIG. 12 Thomas E. Marr, Exterior of the Gardners' Home at 152 Beacon Street, 1900

pregnancy loss dates from the very beginning of their marriage. Burial records related to the Gardner family tomb show that Jack Gardner paid for a plot for a still-born infant who died on September 10, 1860—exactly five months after his and Isabella's wedding. Childbearing was, for a nineteenth-century woman, a primary responsibility and life goal. It is unclear if Isabella became pregnant again during the next two years of their marriage, but there are no records of any other still or live births. In contrast, her sisters-in-law—Julia Gardner Coolidge and Harriet Sears Amory Gardner—each delivered two healthy sons in this period.

As personal struggles consumed them, so too did tensions in the outside world. Through the 1850s, friction between the Northern states and the slave-holding South escalated. The Republican Party formed, opposing the extension of slavery into any new U.S. states and territories. When Abraham Lincoln—the Republican candidate—won the presidential election in November 1860, seven Southern states seceded from the United States within three months. Massachusetts, with its long history of abolitionist activity, was home to Frederick Douglass, famed spokesman against slavery, and was represented in the U.S. Senate by Charles Sumner, who had, in 1856, been violently beaten by a South Carolina colleague who opposed his antislavery views. Despite this reputation as a bastion of abolitionist activism, a clear consensus among

Massachusetts residents about how to respond to the Southern secession and the question of slavery remained elusive.

Boston's elite were divided. Many had been members of the Whig Party (dissolved 1856), which did not take a strong position on slavery, in hopes of preserving economic links between slave and nonslave states. Many in Boston with economic interests tied to maintaining the status quo—including trade in commodities produced by enslaved people—subscribed to the Whig philosophy for decades. This tolerance of slavery contrasted with the Republican Party's explicitly antislavery stance. Around the time of the Civil War, Isabella's close friend Maud Howe Elliott, the daughter of suffrage and abolition activist Julia Ward Howe, was heckled in her dance class by the daughters of elite Bostonian Whigs. As she later recounted, they called her a "nasty abolitionist." In the sphere of exclusive men's social clubs—the natural habitat for a Boston Brahmin like Jack Gardner—these political differences caused a permanent cleavage. Members of the elite Somerset Club quit the organization over its failure to take a staunch pro-Union stance. They then founded the rival Union Club, which pledged unqualified support for the Union cause, which ultimately included the abolition of slavery.

FIG. 13 Isabella Stewart Gardner, *Guest Book, Volume III*, 31 May 1897, pages 98–99

How the young Gardners fit into the political landscape in Civil War–era Boston is unclear. According to his obituary, "Mr. Gardner had no inclination for political office. His preference was for a life of quiet and helpful influence in business and social circles." The Gardners clearly remained loyal to the Somerset, despite the political controversies. Jack's father appears on the membership roster in 1853, early in the club's history, and Jack himself is listed as a member after the Civil War.

Jack did not serve in the Civil War. He likely took advantage of one of the provisions of the Union draft, the Enrollment Act of 1863, that favored wealthier men. These allowed for a conscripted man to find a substitute—his friend T. Jefferson Coolidge paid for a substitute draftee—or, under a commutation clause, to pay $300 (about $6,000 today) to the U.S. government for an exemption. Which provision he invoked is unclear, but Jack remained at home in Boston throughout the conflict.

Isabella's opinions about the Civil War remain as opaque as her husband's. Years later, in 1897, she attended the unveiling of the memorial to the 54th Massachusetts Regiment, a Black infantry regiment raised after the Emancipation Proclamation and commanded by a white colonel, Robert Gould Shaw (fig. 13). The regiment participated in a

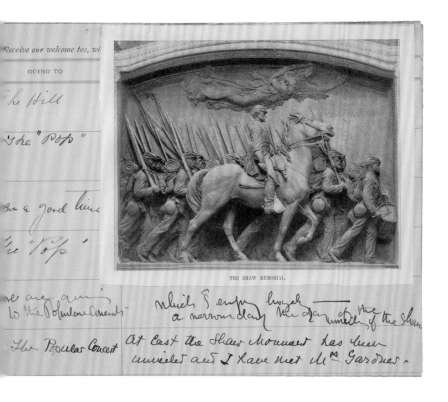

THE SHAW MEMORIAL.

heroic and bloody assault on Battery Wagner, a Confederate position on an island near Charleston, South Carolina. Shaw was killed, as were more than 280 of the regiment's 600 men. One of the survivors of the battle, Sergeant William H. Carney, became the first African American awarded the Congressional Medal of Honor; the heroism of the 54th became legendary and the memorial has a prominent place on the Boston Common. Gardner was friends with Augustus Saint-Gaudens, the sculptor of the memorial, which may be why she attended the unveiling—she may also have believed that the 54th Regiment's heroism deserved to be celebrated and memorialized. However, there are no traces of her memories of the Civil War, nor do her opinions at the time of the conflict survive. Her only statement on the matter—reported by Carter—was that she was "too young to remember it" and too absorbed with the birth of her first and ultimately only child: John "Jackie" Lowell Gardner III.

Jackie was born on June 18, 1863. A photograph shows Isabella posing with her son (fig. 14). In contrast to the handful of other images of her from her early life, which appear stiff and awkwardly posed, this photograph feels candid and maternal. A very youthful Isabella—she was only twenty-three and looks even younger—nuzzles her chin and nose behind the shoulder and ear of her son. Jackie stares straight at the camera, perhaps unaware of how evident it is that she loved and cherished him.

Tragically for his parents, Jackie died not long after the photo was taken. He had probably contracted a childhood cold that developed into pneumonia; he passed away on March 15, 1865, just a few months shy of his second birthday. Isabella was bereft at the loss of her son. Despite all of her privilege, she could not be—and was not—protected from a series of deeply felt losses. As Carter noted decades later, "For many years the anniversary of Jackie's death was spent in seclusion," and in later life "she never mentioned her child."

Losing Jackie marked a decisive shift in Isabella's life. She likely became pregnant one more time after Jackie's death but suffered a miscarriage in the wake of the death of her sister-in-law Harriet, wife of Joseph Gardner, who was one of her closest friends in Boston. An account comes from a letter written by Elizabeth Cabot Lowell, one of Jack's relatives:

> Belle ... had been very delicate since the death of her child and was to be confined again some 4 or 5 months hence. But when Harriet Gardner so suddenly passed away, the servants sent to Jack Gardner [and] Belle did everything for Harriet that she

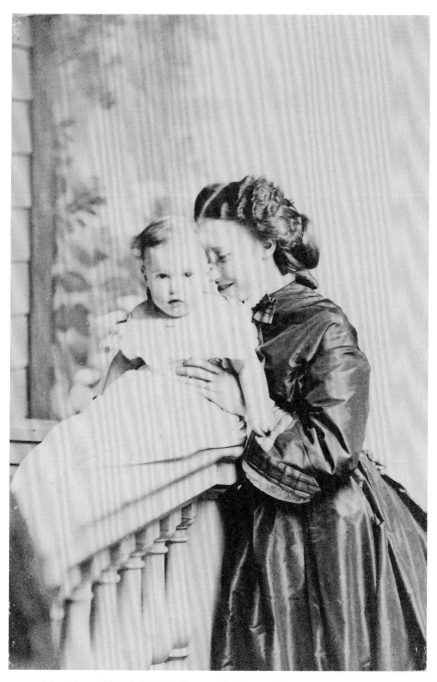

FIG. 14 John Adams Whipple, Isabella Stewart Gardner and her son,
John Lowell Gardner III, 1864

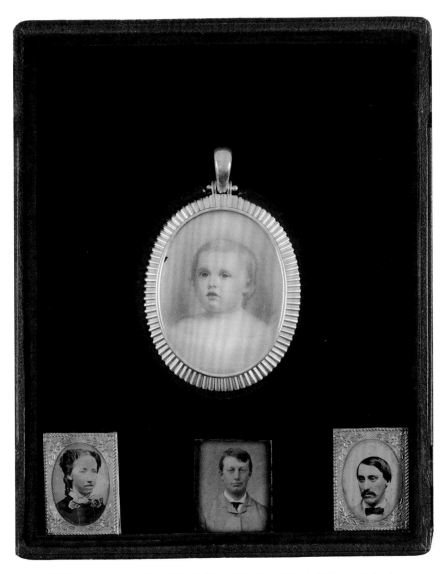

FIG. 15 Miniature portraits of John "Jackie" Lowell Gardner III, Isabella Stewart Gardner, Joseph Peabody Gardner Jr., and John Lowell Gardner Jr.

had insisted upon doing for her own child. She was constantly with Joe, the excitement and shock kept her up until after the funeral, when she was taken ill and remained so for four days before she got through—causing great anxiety—Joseph seemed to forget himself in his solicitude and watched with John [Jack], who never left his wife. Now she is getting on though weak.

"Confinement" was a nineteenth-century term for pregnancy or child-birth. The illness that Isabella suffered therefore may have been another miscarriage. After this loss, doctors appear to have made it clear to her that it would be impossible for the Gardners to have children, and Isabella seemingly fell into a deep depression. According to later sources, the period between 1865 and 1867 was one of her lowest. Doctors apparently recommended that Jack take Isabella abroad in an effort to improve her mental state. This trip was clearly a point of transition in Isabella's life, one that would ultimately lead her to the creation of an exceptional institution: her Museum. A small installation in the Little Salon (fig. 15) still pays homage to Jackie, as well as one of the Gardners' beloved nephews: a miniature of their son, with his life dates engraved on the back, appears over images of Jack and Isabella; later she added an image of Joseph Peabody Gardner Jr., likely after his death in 1886 at the age of twenty-five. It forms an intimate tribute to Jackie and another boy whom Isabella and Jack loved and lost.

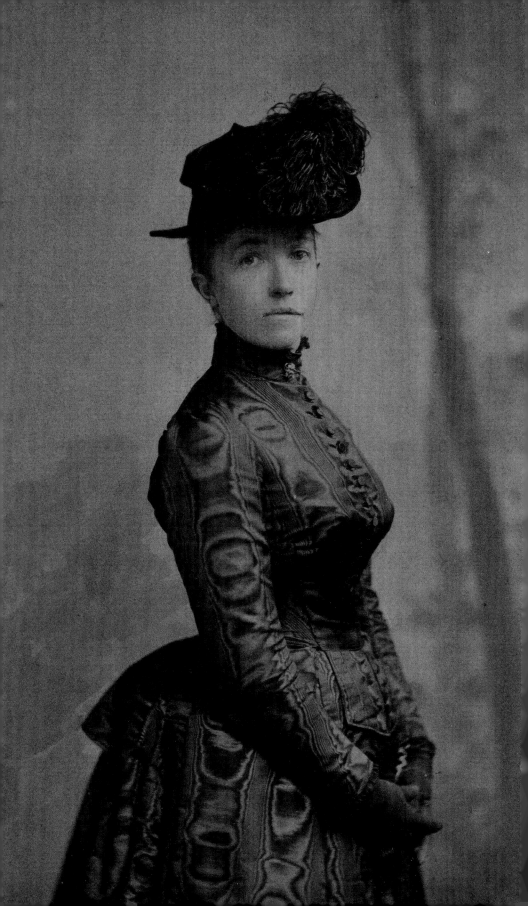

ISABELLA'S EDUCATION
1867–c. 1890

On the far wall of the Titian Room at the Gardner Museum, the painter's imposing *Rape of Europa* confronts visitors directly. Dazzled by its overwhelming size and striking subject, many overlook a much smaller painting intimately situated on a nearby table: *Christ Carrying the Cross*, attributed to the circle of Giovanni Bellini (fig. 16). A tear runs down Christ's cheek; the heightened naturalism demands the viewer's empathy, making us feel his suffering viscerally. In this image, Christ is more man than god. Gardner placed a chair in front of the painting, inviting viewers to rest eye-to-eye with him, to ponder and perhaps to sympathize with his pain. Just to the right of this emotionally charged Renaissance masterwork sits an object that may seem less significant but likely held rich personal meaning for Gardner. The eighteenth-century silver Norwegian beaker, almost certainly acquired in 1867, commemorates the first trip abroad that she and Jack took together (fig. 17). The journey was intended to revive Isabella from the depression that beset her after the death of her son, the passing of her sister-in-law, and finally her miscarriage. With this context in mind, Christ's suffering—a sacrifice that would save the souls of believers—offers a fitting pendant to the souvenir of that 1867 trip.

Gardner's many new experiences in the years following her losses, including the 1867 tour of Scandinavia, Russia, and Central Europe, apparently restored her health and set her on a path to creating her

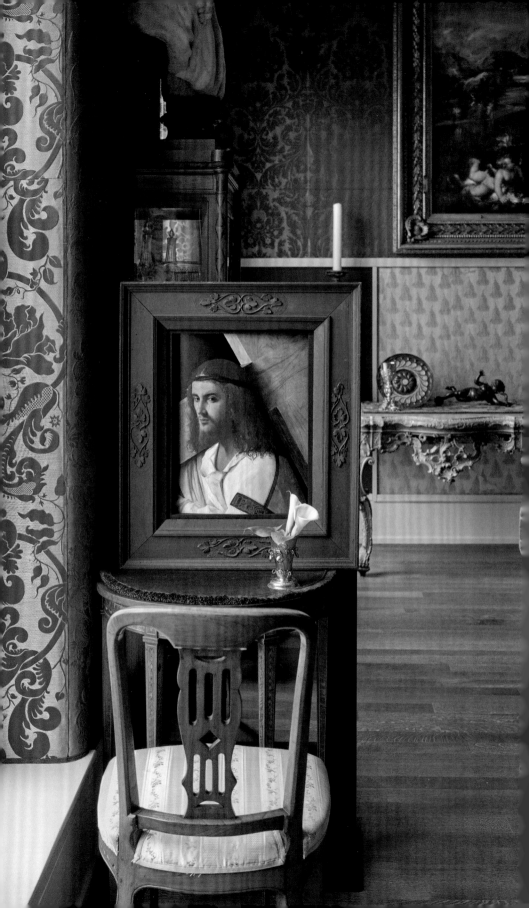

FIG. 17 Isabella Stewart Gardner and John Lowell Gardner Jr. during their visit to Norway, 13 June–17 August 1867

Museum. Her travels—almost always alongside Jack—eventually encompassed thirteen international voyages to thirty-eight countries (using twenty-first-century borders) between 1867 and 1906, when she went abroad for the final time (see Appendix 1). Another venture was Gardner's pursuit of education, undertaken at Harvard, as well as through her own reading and consultation with a growing circle of friends, acquaintances, and mentors who were among the intellectual and cultural elites of her day. Finally, this period marks the beginning of her activities as a collector, starting with rare books, items acquired while traveling, and, increasingly, fine art. While Gardner explored these many interests between the late 1860s and late 1880s, she did not yet plan to become a major art collector or to found a museum. However, in retrospect, these pursuits were formative. They are key to understanding Isabella's personal development, her emergence as a cultural leader, and how and why she went on to create such an extraordinary cultural institution.

We don't know why Isabella and Jack chose to visit Scandinavia and Russia on their first trip—these were not typical European destinations at the time. However, the journey abroad lifted Isabella's spirits. Upon her return to Boston, she reengaged with the perpetual whirl of the city's social scene. Clothed in the latest fashions acquired from

FIG. 16 Titian Room with the Circle of Giovanni Bellini's *Christ Carrying the Cross*, about 1505–1510, and a Norwegian Hanseatic beaker, 18th century

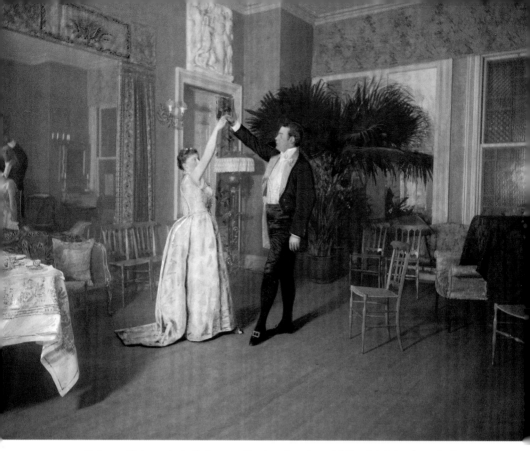

FIG. 18 James Notman, Isabella Stewart Gardner Dancing with Randolph Appleton in the Music Room at 152 Beacon Street, 1891

legendary Paris designer Charles Worth (fig. 18), she reentered society and, according to at least one biographer, became increasingly infamous for breaking the mold of what was expected from a woman of her class.

Gardner caught the travel bug on this first journey, which also set the standard for how she would record and remember her experiences abroad. She established a habit of creating albums to document her trips. By gathering materials and pasting them into bound books, she produced twenty-eight albums between 1867 and 1895, as she traveled the world. Though the composition of each album differs, the hallmark of her practice is collage, bringing together commercial photographs, botanical samples, and paper goods like handbills and invitations (fig. 19). The arrangements of multiple media foreshadowed the layering of objects in her galleries. However, unlike the galleries, the albums represent clearly ordered and almost instantaneous responses to her movements through time and space—including the kind of organization by chronology and geography that she would ultimately eschew in the Museum. Notably, the albums—most of which were produced years before she became a dedicated art collector or had any inkling of founding a

cultural institution—are candid and unmediated by changes of taste or the passage of time. While Gardner was purposely opaque about the logic she used in installing the galleries of her Museum, her immediate responses to foreign cultures collected in her travel albums are frank and revealing.

Of all the albums, the most illuminating and intensely personal is that from Egypt (1874–75). Commemorating the Gardners' first trip beyond the United States and Europe, it served as Isabella's diary and a repository for her watercolor sketches, as well as for gathered materials typical of the other albums (fig. 20). Isabella carefully documented each stage of a sixty-four-day journey up the Nile that she and Jack took on a chartered *dahabiyya*, a traditional Egyptian sailboat. Predictably, her diary entries express the standard biases of a wealthy, white, nineteenth-century American woman traveling in the Middle East for the first time. In particular, her initial comments indicate that Isabella was seeking—and found—experiences informed by the role of Egypt in the Bible, as well as by the stories in collections like *The Arabian Nights*, which were the basis of exoticized images of the region. However, Isabella generally expresses an awe and appreciation for what she sees. An example of the depth of her gratitude for the journey is the diary entry penned on the day she and Jack reached their southernmost destination on the river, the Second Cataract and Rock of Abusir:

> Following the McClellans' advice (which was of the best) we went to Abouseer [*sic*] by boat . . . it was 20 minutes of 7 before we sailed and rowed away in the very craziest of crafts. Our ordinary rowboat; a mast manufactured out of odd poles, one of the linen sheets for main sail and a flying jib made of the awning. It was such a fresh pleasant way of getting to the mountain and it was very interesting threading our way thro' the 1000 islands of the 2nd cataract. A little climb to the top and a most startling picture at our feet. No end of Nubia in one direction; directly under our feet the black rocks jutting up in the rapids and such myriads of them and off to the south, as much as one chose to imagine. I hunted amongst the carved names for those of friends and found several, as well as the historical ones. Whilst J. was busy scratching "Gardner" I had the top of the mountain all to myself and there was nobody to laugh at me for being absolutely unhappy because our journey was over and our faces were to be turned to the north even in ½ an hour.

FIG. 19 Isabella Stewart Gardner, *Travel Album: China and Japan*, 1883, pages 53–54

Ozaka —

TENOJI.

SITENOJI.

KOBAIBASHI.

CASTLE.

CASTLE.

OLD CASTLE & BARREK.

FIG. 20 Isabella Stewart Gardner, *Travel Album: Egypt*, 1874–1875, page 10

Isabella would later take some Egyptian sand, preserved in elaborate glass bottles, and keep it with her—making them the centerpiece of a table arrangement in a gallery called the Macknight Room (fig. 21).

The Gardners' trip to Egypt and the Middle East changed their lives in more ways than one. While still abroad, they received a telegram that Jack's brother Joe had died. Predeceased by his wife, Harriet, Joe left three sons—Joseph, William Amory, and Augustus, ages fourteen, twelve, and ten—now orphans. Isabella and Jack, who was legally one of their guardians, brought the boys to live with them.

Isabella took their education in hand, and the boys' Latin, Greek, history, and literature studies seem to have inspired her own pursuit of further education. She began to assemble a substantial library. Literature was her gateway to history, spanning ancient Greece and Rome to the present. Indeed, poetry, at least as much if not more so than painting, was essential to her nascent vision of the historical past. In her copy of William Roscoe's *Life of Lorenzo De' Medici* (she owned the 1883 edition), Gardner did not single out any of the illustrated paintings or statues made under Lorenzo's patronage but instead characterized a poem by the Florentine Francesco Baldovini as "the most beautiful of all."

FIG. 21 Macknight Room with Isabella's bottles of Egyptian sand

Though her formal education was limited by her gender, Gardner—by virtue of her class and financial resources—transcended social expectations by gaining access to leading intellectuals at Harvard University and some of the courses they taught. Above all, she became entranced by the Italian poet and writer Dante, who became her window into a new world. In March 1878, Gardner purchased a season's ticket to readings of Dante by Charles Eliot Norton, who held the position at Harvard of "Lecturer on the History of the Fine Arts Connected with Literature"—the first art history professorship in the United States.

Norton was the leading American follower of John Ruskin (1819–1900), a prolific British art critic and social thinker who wrote about the importance of aesthetic beauty—both in art and in the natural landscape—and advocated for the preservation of historical buildings in the face of industrialization. He argued that the Divine infused all of these things: art, nature, and relics of the historical past. Norton helped to convert Gardner to Ruskin's gospel, with a particular focus on Italy and Italian history. Fascinated by these subjects, she also enrolled in his classes on art. Some of her meticulous notes from readings about Renaissance painting—Italian and Northern European—are preserved in the Museum's collection (fig. 22).

As a complement to Gardner's world travels, her enrollment at Harvard introduced a new mode of culturally enriching experience that expanded her education and intellectual horizons. Isabella took Norton's classes through a program called the Harvard Annex, which gave women limited access to the university's professors and courses. She became a lifelong donor to the program, which later developed into Radcliffe College, the women's college of Harvard. Elizabeth Cary Agassiz, the cofounder and first president of Radcliffe was a lasting friend. Between her access to professors and her connections to current students—possibly facilitated by nephew Joseph Peabody Gardner Jr., who started as an undergraduate at the university in 1878—she began to form bonds that would shape both her education and art collecting in the coming years. Her fellow students, in particular, held views that were at the cutting edge of contemporary taste and social opinions. They included Edward "Ned" Perry Warren, son of a Boston socialite, who was openly gay and became a prominent advocate for the acceptance of homosexuality; poet Logan Pearsall Smith; and future art collector Grenville Winthrop. Gardner began to develop a social circle of people like her, who also felt the pressures of rigid social norms and sought to defy them.

Dante's poetry led to several of Gardner's most meaningful relationships. Her friendship with Francis Marion Crawford, a member of

1883

V. S.

Cimabue —

Died, when he was sixty years old, in year 1300

Cotemporaries

Reign — Lewis IX of France —

was of noble family & was sent to study letters at the Convent of Santa Maria Novella. When some Greek artists came to ornament the convent church with paintings, he abandoned studies to which he was little inclined & devoted his attention to watching them & was finally permitted to assist them — Studying hard he soon became one of the best painters of Italy.

His fame having spread abroad he was invited to adorn the church

FIG. 22 Isabella Stewart Gardner, *Notebook with History and Art History Notes*, 1883, page 1

Norton's circle, became a source of public speculation and potential scandal. Crawford was the nephew of Isabella's close friend Julia Ward Howe. Fourteen years Isabella's junior, he was born and raised in Italy, studied at universities across Europe, and traveled to India in 1879 to learn Sanskrit. In the winter of 1881, Crawford arrived in Boston to live with relatives who had become concerned about his career prospects. He continued his study of Sanskrit at Harvard and joined Norton's Dante study group, where he met Isabella.

The two did not hide their affinity for each other, apparently shocking Boston society and worrying his family—indeed, Gardner's earlier biographers have reveled in this scandal and portrayed her as a flirt and chaser of younger men. While it remains unclear if the two had a physical affair, she later displayed his letters, books, and manuscripts in the Crawford/Chapman Case in the Museum's Blue Room. Several objects in the collection reveal the pair's deep affection for each other, particularly a photograph taken in 1882, when Isabella was forty-two and Crawford twenty-eight, showing their hands clasped together (fig. 23). During his stay in Boston, Crawford wrote his first novel—*Mr. Isaacs* (1882)—which was an immediate success. Yet the young author left abruptly in the spring of 1883 and returned to Italy, where he lived for the rest of his life, becoming a prolific writer and a married father of four children.

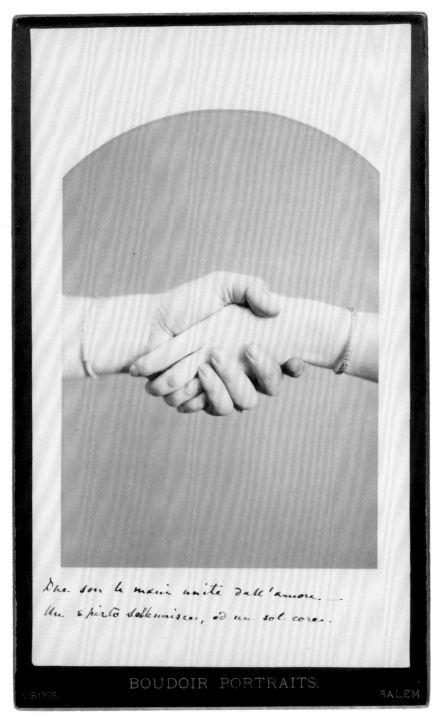

Due son le mani unite dall'amore —
Un spirto solkenmisca, ed un sol core.

BOUDOIR PORTRAITS.

CROSS. SALEM.

FIG. 23 A. B. Cross, Clasped hands of F. Marion Crawford and Isabella Stewart Gardner, about 1882

FIG. 24 Dante Alighieri and Tiffany & Company, *The Divine Comedy*, 1879

The friends were clearly very important to each other and remained so for some time. A decade after he left Boston, Crawford and Isabella reconnected, and in 1893, he gave her a very special gift. He sent their copies of Dante's *Divine Comedy*—presumably the ones they had used in Norton's group—to Tiffany & Company to be interleaved and exquisitely bound together in green leather and silver (fig. 24). On the combined volume's silver clasp is written "The two are one," and on the first page an excerpt from *Paradiso* (33.86–87) appears: "Legato con amore in un volume / ciò che per l'universo si squaderna" (Bound with love in one volume / all that is scattered throughout the universe). Gardner kept her volume in the Dante Case in the Long Gallery of the Museum. There is no record about how Jack Gardner felt about this connection—either in the 1880s or when the duo rekindled their friendship in the 1890s.

When Crawford left Boston suddenly for Italy, Isabella also took to the road. In the spring of 1883, she and Jack departed for the trip of a lifetime that would take them around the world, stopping in nineteen countries. The journey began with a cross-continent train ride to San

Francisco, followed by a trans-Pacific voyage by steamer to Yokohama, Japan. From there, they traveled throughout Asia, concluding with an extended stay in Venice—Isabella's first time back since her teenage visit decades earlier—followed by some time spent in Paris and London. They sailed for home from Liverpool in July 1884.

The Gardners' most ambitious trip was formative for Isabella, who later developed an interest in collecting Japanese and Chinese art. But already in the 1880s, she and Jack acquired a range of souvenirs and developed an interest in Japanese art that would lead to the acquisition of important screens like those featuring *The Tale of Genji* (fig. 25). While Jack's diaries from the trip record kilometers traveled and money spent, Isabella's diary and series of collaged travel albums reveal a much more personal and immediate reaction to what she saw.

The chronicle of her trip to China offers a compelling example. The Gardners arrived in Shanghai from Japan in the autumn of 1883. From

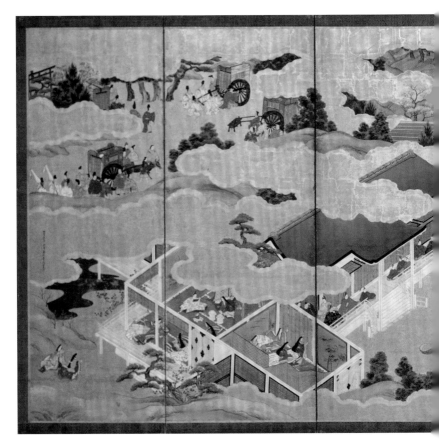

FIG. 25 Kano Tsunenobu, *Scenes from the Tale of Genji*, 1677

her first day in what she referred to as the Middle Kingdom (a literal translation of a traditional Chinese name for China), Isabella recorded a wide variety of experiences, from the unique to the everyday. Her elaborate albums attest to the impression that Chinese culture made on her. They include pictures she acquired of sights she visited, street scenes, and "characteristic" local people—these subjects were typical of commercial travel photographs sold to tourists and visitors around the globe during the nineteenth century. She also pasted in papers, such as calling cards, and the occasional pressed flower or plant. The resulting albums are beautiful blends of visual records and found objects.

The couple's ultimate goal was Beijing, which Americans called Peking at the time. In the 1880s, access by visitors was restricted. From Shanghai, Jack and Isabella had to travel by boat and mule to reach their destination. On September 24, 1883, she described Beijing, her excited impressions evoking its sights and sounds:

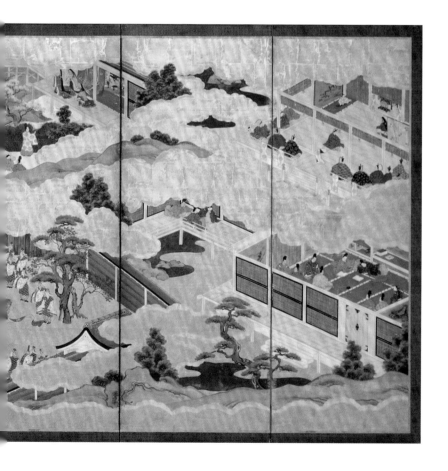

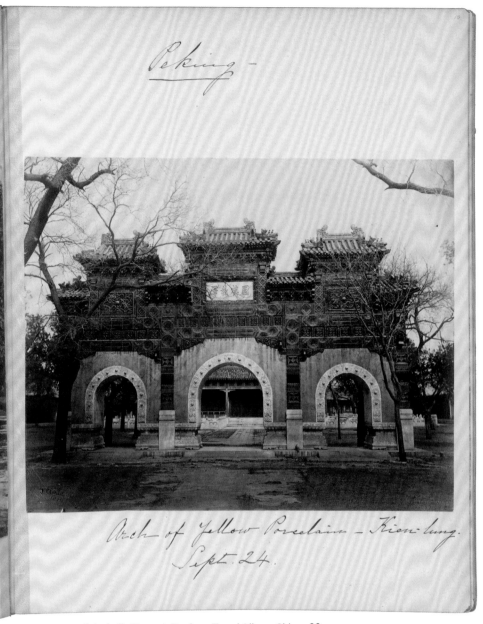

Peking —

Arch of Yellow Porcelain — Kien lung.
Sept. 24.

FIG. 26 Isabella Stewart Gardner, *Travel Album: China*, 1883, page 10

A short spell of curio dealers then off . . . to the Gate Qianmen opposite the entrance into the Imperial City. Had good view from there. Yellow tiles glistening everywhere. . . . The Clerk of the Legation . . . took us to see the Temple of Confucius, the Pavilion of Kien Lung [Qianlong] and beautiful arch, then to Lama Temple. The latter of strange and very interesting architecture—court after court—all the Lamas in yellow cloaks and such strange yellow hats. Services going on, one of them in

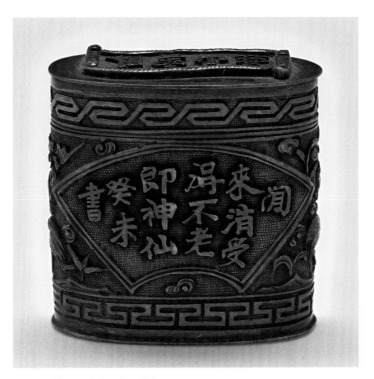

FIG. 27 Chinese, *Opium Box*, 1883

open court, consisting of odd chanting in very low voices,
with an accompaniment of clapping together two pieces of
wood. In one of their temples a very large gilded Buddha,
standing. In another beautiful T[i]betan carpets and cloisonné
altar decorations.

One of Isabella's travel albums includes a photograph of the arch
with yellow tiles that she saw on that day (fig. 26), and the Museum's
collection still includes some of the souvenirs that she purchased
in China—possibly in Beijing—for example, an opium box inscribed
with a poem (fig. 27).

The passage from Gardner's travel diary emblematizes her
reactions to the many foreign cultures she experienced during this trip
in several ways. She was generally earnest in her interest in and engage-
ment with what she encountered and rarely left condescending remarks
about the people or places she saw. She sometimes reveled in the
"exoticism" of non-Western practices—like riding an elephant, as she
did in Cambodia to tour the temples of the Angkor Wat complex. And
the photographs she chose for her albums sometimes feature ethno-
graphic images of the people who lived in the places she visited, or

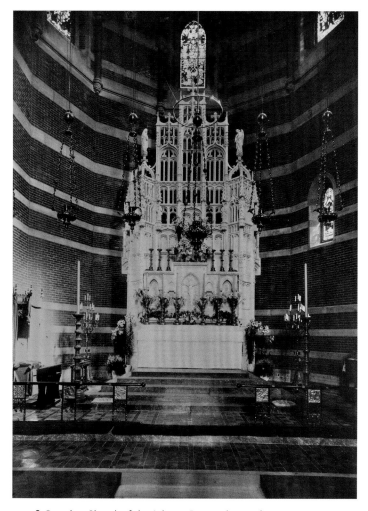

FIG. 28 Reredos, Church of the Advent, Boston, late 19th century

positioned local residents as picturesque props in a broader composition. But in general, her tone is one of awe rather than of dismissal of these people and cultures—unlike the attitude of some American and European travelers of her wealth and class. Nonetheless, her trip was facilitated by global imperial networks that increasingly colonized countries beyond the European continent and imposed exploitative forms of rule. While she may not have been directly engaged in an imperial enterprise, her travels intersected with, and were facilitated by, this expanding colonial regime.

Gardner's reaction to the chanting of the Buddhist monks (the "Lamas") points to her growing interest in spirituality. The appeal of sensory experience informed her enthusiasm for rite and ritual across

religions. A practicing Episcopalian throughout her life, Isabella joined Emmanuel Church in Boston but later changed her affiliation to the High Anglican Church of the Advent (the "High" meaning a more ornate, elaborately ritualistic Episcopalian tradition, and Anglican being the term for the official Church of England). Throughout her life she donated to Anglican causes around Boston and was known for her enthusiastic observance. At the Church of the Advent alone, she provided the high altar reredos (fig. 28), remodeled the rector's room after a painting of Saint Jerome's study, and became head of the Altar Guild, wearing the customary blue habit to wash the altar. An 1891 article in the *Boston Courier* stated: "There never existed . . . a more zealous churchgoer than this same shining leader of society. . . . In Lent several times a week [Mrs. Gardner] dons a raiment of sackcloth, or its modern substitute, serge, and goes to clean the brasses in the chancel."

Despite her clear dedication to the Episcopal tradition, Gardner's religious interests were not limited to her own faith. Rather, her piety fueled a fascination with other religions. Catholicism captivated Gardner at a time when the Roman Church in Boston was closely affiliated with poor, working-class immigrants, largely of Irish and Italian origins. Gardner attended Catholic services abroad and, years later, received the honor of an audience with the pope in Rome. Catholic rites and rituals made the past present, appealing to her sense of history as lived experience. The rituals of Eastern religions fascinated her as much as those of the West. In addition to her recollection of the chanting monks in China, she attended, on the same trip, a service in a Buddhist temple in Nikko, Japan. Her engagement with Buddhist ritual in Asia reveals a global exploration of religion uniting her devotions to aesthetics and spirituality. Much of the art Gardner encountered on her trips—and that she would later collect—was religious and served a ritual purpose.

Venice concluded the tour of Asia. She wrote on May 13, 1884: "Strange morning. The sea like oil—and boats all yellow and red sails. An idle delicious looking at it—i.e. the sails, the strange sea, and Venice afar off." Having taken classes on Italian art with Professor Norton and read the works of Ruskin—his classic book *The Stones of Venice* (1851–53) remains in the Museum's collection and is inscribed "I. S. Gardner April 17, 1882"—Gardner was primed to view Venice as an essential cultural and even spiritual experience. Accordingly, she dedicated an entire elaborate travel album to the city, carefully documenting the art, churches, and—as per Ruskin's directives—what were considered picturesque ruins of past Venetian structures (fig. 29).

Practically speaking, Venice's rootedness in the past and the perceived aristocratic decline that so appealed to Isabella, Ruskin, and

FIG. 29 Isabella Stewart Gardner, *Travel Album: Italy,* 1884, page 3

many others were the result of economic collapse. In 1887, three years after the Gardner's visit, the city was still largely unmechanized and men who could find work made around 2.5 lire per day. Things eventually became so dire that, at the turn of the century, Venice's beloved bell tower in Saint Mark's Square collapsed. Foreign tourists sponsored artisanal and crafts businesses that resonated with their ideas of the city's glorious past but did not encourage the heavy industry that could have lifted the local population out of poverty, and instead complained of the large wakes in the lagoon from steamships. In this period, in Venice as elsewhere on the Italian peninsula, antiques shops and art dealers began

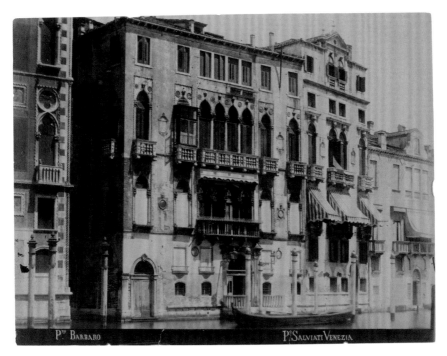

FIG. 30 Palazzo Barbaro and Palazzo Salviati, Venice, late 19th century

to flourish, satisfying the demand for objects from moments in the past
so idolized by Gardner and her contemporaries but not yet valued as a
collective patrimony by a fledgling Italian nation.

However, arriving in 1884, Isabella adopted a particular point of
view that set her apart from most of her fellow American visitors: she
approached Venice from Asia rather than from other locations in Italy or
Europe. While Ruskin's book had described the importance of Venice as
a crossroads between European, North African, and Middle Eastern cul-
tures, Isabella was able to experience this fact directly. Her appreciation
of the city as a nexus of trade and cross-cultural interactions likely
informed the global scope and multicultural character of her collection
and the museum built to house it.

Palazzo Barbaro on the Grand Canal became a home-away-
from-home for the Gardners and revealed to Isabella the potential of
architecture as a palace of memories. The upper-crust Bostonians
Ariana and Daniel Curtis first rented the palazzo in 1881 and purchased
it in 1885 (fig. 30). The grand but decaying aristocratic home became a
hub for artists, writers, wealthy American expatriates, and the occa-
sional minor European aristocrat passing through the city. Members of
the circle included the likes of painters John Singer Sargent and James
McNeill Whistler, and writers Henry James and Violet Paget (who used

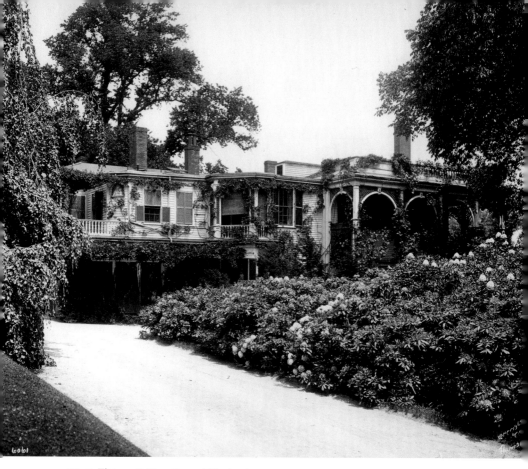

FIG. 31 Thomas E. Marr, Green Hill, about 1900

the pen name Vernon Lee). Even the French Impressionist Claude Monet visited. The first experience of spending time among the salon-like circle and being in the picturesque setting of the palazzo enchanted Jack and Isabella—they returned for an extended visit nearly every other year and rented rooms there. Furthermore, on their return to Boston in the fall of 1884, Gardner constituted in earnest her own circle of intellectual and artistic friends who would become her lifelong interlocutors, companions, and sometime art advisors. In this sense, even before building the Gardner Museum, she brought a part of the Palazzo Barbaro to New England.

Jack's father died that summer while they were abroad, and Jack and Isabella inherited the family property called Green Hill in Brookline, the town west of Boston (fig. 31). This became one of their most cherished places. The elder Gardners had purchased the white-and-green house with a vine-covered, two-story arcade in 1842 as a summer estate. Built in 1806, the home was perched at the top of a sloping hill surrounded by grassy lawns and fields. It was the potential of the pastoral setting that captivated Isabella. She transformed the land into a haven

FIG. 32 Thomas E. Marr, Isabella Stewart Gardner in the Conservatory at Green Hill, late 1890s

for her horticultural pursuits and established her reputation as a creative landscape designer and talented gardener (fig. 32). She could not do this work alone. The 1900 census shows seven people living and working on the estate, the majority of whom were immigrants from Europe. The grounds were managed by head gardener Charles Montague Atkinson (1826–1896), who had been on the family payroll for almost two decades. Born and trained in England, Atkinson was well known as a skilled plantsman: his flowers, vegetables, and orchids were frequent prize winners at the Massachusetts Horticultural Society. He bristled at

change, but Isabella had a clear vision: she wanted visitors to experience the world in the grounds. Surely inspired by her recent circumnavigation of the globe, she created both an Italian and a Japanese garden. The home became a welcoming environment for the many artists, musicians, and intellectuals whom she and Jack hosted in Brookline.

In addition to their primary residence on Beacon Street and the estate at Green Hill, Isabella and Jack also made use of two houses in Prides Crossing on the North Shore of Massachusetts. These were originally owned by Jack's brother Joseph, who left them to his sons when he died. Isabella rented the homes—Beach Hill, a Queen Anne shingle-style house, and Alhambra, a white colonial—from Joseph's estate (fig. 33). Customarily she and Jack spent the spring at Green Hill and summer and early autumn in Prides Crossing, with the occasional trip to Roque Island in Maine (fig. 34)—a property inherited by Jack's mother, Catherine Peabody Gardner. In later years, Isabella stayed at Green Hill during the summer until late into the fall.

Isabella and Jack spent falls and winters on Beacon Street, and in 1885 Isabella once again returned to her Harvard circle. Now a confirmed Italophile, she was inducted into Professor Norton's Dante Society and

FIG. 33 Isabella Stewart Gardner in the Sitting Room at Beach Hill in Prides Crossing, Massachusetts, 1884

FIG. 34 Isabella Stewart Gardner and her niece Olga Monks (paddling) in a birchbark canoe named *The Owl* in the Roque Island archipelago, Maine, about 1896

began to buy manuscripts and rare printed editions of canonical Renaissance classics at his direction. At the 1886 sale of a private collection in London, on Norton's advice Gardner purchased two illuminated manuscripts of Dante's *Divine Comedy* and rare editions of the *Hypnerotomachia Poliphili* and Petrarch's poetry, both printed by Aldus Manutius, Italian humanist and founder of the Aldine Press. One year later she acquired a collector's edition of Dante, this one printed in Florence in 1481 and illustrated with metalcuts after designs by Botticelli, bringing the first authentic works by this artist to the United States.

Dante indirectly laid the groundwork for another transformative relationship. It was likely through the circle of Harvard students she knew that Gardner met the budding art historian Bernard Berenson in 1886. Born in Lithuania to a Jewish family whose lumber business and home were destroyed in waves of racist violence, Bernhard Valvrojenski was brought to the United States in 1875 when his family immigrated. They settled in Boston, and his father, who believed in assimilation, immediately Americanized their name to Berenson, the first in a series of conversions. In 1885, the Harvard student embraced the Episcopal Church, and then in 1891 converted to Catholicism. During the First World War, he Anglicized his first name to Bernard. These changes reflect his

evolving identity, a powerful reminder that Gardner befriended not only outsiders but also people who refused to allow society to define their place in it. She may have been particularly sensitive to young outsiders at Harvard. Her nephew and charge Joseph Peabody Gardner Jr. died by suicide for unknown reasons in 1886, some four years after graduating. A suggestive circumstance: his close college friend Ned Warren was openly gay, even though it was both socially unacceptable and illegal. While Warren ultimately wrote a book defending same-sex love and moved to England to live with his partner, it seems that Joseph Gardner may have buckled under the pressures of living in a society that rigidly excluded sexualities not strictly considered the norm.

Berenson not only engaged with Ruskin's theories but also venerated the work of the English philosopher Walter Pater, credited with pioneering the idea of "art for art's sake," which states that art does not need to serve political, religious, or didactic purposes. For Pater, art was an end in itself, and the Italian Renaissance was fundamental to the formation of this conviction. Pater envisioned the period as a realm of imagination, sensation, and possibility, as outlined in his essay collection *The Renaissance: Studies in Art and Poetry* (1873). Perhaps at the urging of Berenson, or students in his circle, Gardner acquired two copies of Pater's novel *Marius and the Epicurean* (1885).

Gardner's embrace of Berenson and Pater signaled her view of art as not only intellectual and historical but aesthetic. While in London in 1886, she met Pater, who wrote her a short note. Back in Boston, she dined with Oscar Wilde and later received from a friend a copy of his scandalous poems to lover Alfred Lord Douglas. Many books of poetry in her library—including the erotic *Chansons de Bilitis* (1894) by Pierre Louÿs—situate Gardner's taste for the hedonistic at the avant-garde of Boston intellectual currents. By the late 1880s, the Boston Public Library had consigned works by Wilde, Émile Zola, and Algernon Swinburne, as well as other Aesthetic Movement writers, to a list titled "Books in Inferno," effectively a permissions shelf that restricted public access. They would later add Boccaccio's *Decameron*, one of Gardner's favorite Renaissance works.

A year later, in 1887, Gardner changed the course of Berenson's life. He had been rejected for a travel fellowship that would have allowed him to go to Europe, in part as a result of the anti-Semitism of his professor, Norton. In response, Gardner teamed up with Ned Warren and another benefactor, Thomas Sergeant Perry, a Harvard English professor, to make the experience possible. Berenson's departure for Europe marked a turning point that set him on course to become a groundbreaking art historian, renown connoisseur, and Gardner's principal art agent and advisor.

FIG. 35 Henry James, 1880s

Berenson was one of several people who would contribute importantly to Gardner's opinions, knowledge base, and tastes during this period. She engaged with a large network of impressive friends, including a profoundly literary crowd. For example, she befriended author Annie Fields and her companion Sarah Orne Jewett, who was best known for portraying New England life in novels such as *The Country of the Pointed Firs* (1896). The two shared a home in Beacon Hill and hosted literary gatherings that included people like Mark Twain and Willa Cather. Gardner's other writer friends included the Irish dramatist Lady Gregory and the poet Amy Lowell. But perhaps her closest literary friend was celebrated author Henry James (fig. 35). For almost forty years, the two wrote to each other regularly, exchanging insights, anecdotes, advice, jokes, and gossip. They visited each other in America and England, and enjoyed holidays together in Venice. They shared an understanding that all forms of art—from literature to the visual and performing arts—are one, and that artists, working in whatever medium they choose, share creativity as a common language.

During the 1880s, while Jack and Isabella continued to travel and learn, their engagements with art and art collecting were run-

of-the-mill for their class. Their earliest activities reflect an interest in contemporary French art typical of their Boston peers and recalling Isabella's schooling and year abroad in Paris. Like many upper-class Bostonians, Gardner bought French works of the recent past and the present, above all landscapes by painters of the Barbizon School and their American followers. In 1868, she purchased *An Old Barn under Snow* by John La Farge, an American artist influenced by his French contemporaries. She followed it with works by Gustave Courbet, Narcisse Virgile Diaz de la Peña, William Morris Hunt, and Charles-Émile Jacque, all Barbizon School painters or followers of them. Her purchases also included *The Crusader* by Eugène Delacroix, the French Romantic painter, in 1882, which remained her most expensive acquisition until 1892. Few of these choices set her apart; rather, they aligned her with the trustees of Boston's Museum of Fine Arts, for whom her husband became treasurer, and other American collectors of the time like Henry Clay Frick.

Similarly, her decision to commission John Singer Sargent was not surprising. The two met in 1886, when he was already becoming the favored portraitist of wealthy nineteenth-century American elites. Sargent created a unique image that married Isabella's interests in East and West. To Henry James it recalled a Byzantine Madonna with a halo, but to a collector of Japanese art it resembled Kannon, the goddess of mercy. Yet his 1888 canvas of her (fig. 36) also stood out for the controversy it created. Isabella's dress was exceptional in what it revealed of her body. She may have enjoyed the scandal, but Jack seems to have asked his wife not to show the portrait again publicly while he was alive. Isabella kept it in a gallery inaccessible to the public for the duration her lifetime.

If the Gardners' collection up to 1890 could hardly be described as pioneering, an event of 1891 transformed it. Her father, David Stewart, passed away and, as his only surviving child, Gardner inherited $2.75 million—equivalent to about $78 million today. Her and Jack's combined fortune would amount to approximately $5 million, which is around $142 million today. Although a tremendous sum, which placed them in the top tier of wealth in the United States, it was not nearly enough for a collector to challenge the titans of American industry—men like Andrew Carnegie, Henry Clay Frick, and the banker J. P. Morgan—as Gardner was certainly aware. She once lamented, "Woe is me! Why am I not Morgan or Frick?" Nevertheless, the inheritance transformed the scope of her ambitions, offering her the prospect to realize, object by object, a collection reflecting her personal vision of the most important art and relics of the past. She was, in a sense, given license to create a cultural phenomenon.

FIG. 36 John Singer Sargent, *Isabella Stewart Gardner*, 1888

The

Isabella *Stewart*

useum *in the*

enway

ART COLLECTING
IN EARNEST

1890–1896

With its terracotta roof tiles and taupe brick facade, the imposing build-
ing rising out of the Boston Fens, beside the Muddy River, looks like it
belongs to a distant era. Fenway Court, as the Museum was known during
the lifetime of Isabella Stewart Gardner, is sparsely decorated on the
outside, with the notable exception of a coat of arms featuring a phoenix
rising from the ashes (fig. 37). Commissioned by the founder from her
friend, the artist Sarah Wyman Whitman, it resembles the heraldry of
European aristocrats, suggesting an ancient past and contributing to the
Museum's patina of age. Yet this is all an illusion. The Museum and its
collection are twentieth-century inventions, modern creations conceived
and executed by Isabella Stewart Gardner. So successful was Gardner at
seamlessly integrating the Museum into Boston's history, that she inad-
vertently obscured its unique origins and innovative contributions, well
ahead of their time when the Museum opened in 1903.

By 1940, Gardner's accomplishments were already shrouded in
nostalgia. Local author Van Wyck Brooks characterized the Museum,
which he called "Mrs. Jack's Venetian Palace," as a natural consequence
of the city's good taste. The author described "Boston girls" growing up
with "Botticelli manners." He cited the important influence of Harvard
and the patrician donors to the Boston Public Library, which was "quite at
home in a town where Italian studies, fostered by [Charles Eliot] Norton
and [Henry Wadsworth] Longfellow . . . were a part of the atmosphere

FIG. 37 Designed by Sarah Wyman Whitman, Crest of the Isabella Stewart Gardner Museum, about 1900

that all men breathed. Dante, Petrarch, Ruskin and Browning were Boston citizens in their way." The author also noted Gardner's prestigious collection of artist friends, citing their design contributions: "Whistler was invited, along with Sargent and E[dwin] A[ustin] Abbey, not to speak of [Pierre] Puvis de Chavannes, to decorate the walls of the Library; and meanwhile the college settlements ministered to the arts and crafts, and the Copley prints appeared, and Poet-Lore. There was a

rage for poems about Titian's garden. The Symphony advanced from triumph to triumph, and the 'sublime sweet evening star' of Wagner eclipsed for the moment Emerson's morning star. The clever Mrs. Gardner did the rest."

Brooks, and many other writers too, mythologized the origins of Boston's reputation—the male leadership, Italian flavor, medieval flair, and later High Renaissance turn—subsuming Gardner's Museum into a product of the place and time. From this sentimental haze, she emerges not as innovator but as a colorful consequence, the example sine qua non of her moment rather than the path-breaking initiator of it. The image persists to this day. Contemporary authors frequently mention Gardner among the ranks of Gilded Age collectors and museum builders such as Henry Clay Frick, J. P. Morgan, and Henry Walters, but rarely distinguish her contributions as preceding theirs.

Gardner created the first purpose-built museum established in the United States by a woman. She brought the debut works by many leading Italian Renaissance artists to the country, among them Botticelli, Raphael, and Titian. She was a pioneer in the collecting not only of Renaissance art, but also of stained glass, Romanesque sculpture, and Chinese antiquities, among other art forms and periods. Hardly aiming to replicate the environment of any of these diverse epochs, Gardner instead envisioned her own idealized, historically inspired setting, curating her collection, the building, and its installation as carefully as she did her own life. Her Museum reveals a vision of history that does not divide and categorize but unites: ancient with modern, East with West, Christianity with Buddhism and other religions from around the globe. Gardner embraced modernity and broke new ground in museum building and the formation of taste in Gilded Age America.

When Gardner first showed an interest in collecting art, in the 1870s, Renaissance art was not a priority for American buyers, if it was available at all. Despite an exhibition of Italian medieval and Renaissance paintings mounted shortly after her arrival in Boston— held at the gallery Williams and Everett in 1862, organized by James Jackson Jarves, and supported by Gardner's mentor Charles Eliot Norton—few early Italian paintings had landed in permanent homes. While the market for Old Master paintings favored European Baroque artists, like Carlo Dolci or the Carracci brothers, their works remained unaffordable for most collectors. In 1871, possibly in an attempt to acquire a European Baroque painting, Isabella purchased a pendant pair of portraits at a local auction of items recently confiscated from convents and monasteries by the Mexican government. The sale catalogue attributed this pair to Miguel Cabrera, an early eighteenth-century

painter of indigenous and Spanish descent who emulated European counterparts and became the most celebrated painter of New Spain.

The period's narrow focus on the Baroque left earlier opportunities untapped. Edith Wharton looked back to this moment in her novella *False Dawn* (1924), in which the heir to a New York industrial fortune is sent to Europe by his father to buy pious Baroque paintings out of the family's price range and returns instead with early Renaissance works by Giotto, Piero della Francesca, and others. As a consequence, the father disinherits his son, who puts the works on public display but never finds a buyer and dies in poverty. Although Wharton wrote the story later, she was recalling the mid-nineteenth century and ensuing decades, when, for most American collectors, Renaissance pictures were simply too avant-garde, except for the rare individual who embraced their often disturbing subjects and could recognize market opportunities.

Isabella Stewart Gardner was that collector. An early hint of her shift in taste was manifest in the renovation and furnishing of her home at 152 Beacon Street. In 1880, the Gardners embarked on a significant expansion, purchasing the neighboring residence and commissioning local architect John H. Sturgis—who had created the old Museum of Fine Arts building at Copley Square as well as the Church of the Advent in Boston's Beacon Hill neighborhood—to merge it with their first property. The dramatic transformation opened reception areas otherwise impossible to realize in narrow Boston townhouses, resulting in expansive suites of the kind found on the *piano nobile* (main floor) of aristocratic Italian palaces (fig. 38). Whether or not the resemblance was deliberate, Isabella began to fill these rooms with Italian furniture, often bought in Venice; French Empire–style cabinets and armchairs (supposedly made for Napoleon but, in fact, forgeries); and Chinese black hardwood furniture, as well as silks and other souvenirs, from the Gardners' 1883–84 journey in Asia.

Following her windfall inheritance from her father in 1891, Gardner wasted little time in becoming a serious art collector. Just a year later—in the fall of 1892—she surprised the art world with the purchase of a major European Old Master painting. In Paris, she commissioned an art dealer to bid on Vermeer's *The Concert* by prearranged signal, instructing him to keep bidding until she put her handkerchief down. Gardner succeeded, trumping London's National Gallery and the Musée du Louvre by buying the painting for 29,000 francs (about $176,000 today). While a major shift in her level of expenditure and quality of acquisition, this did not represent a major departure from tastes of the period. She may have been attracted to the canvas because Vermeer's girl at the piano reminded the collector of herself, as

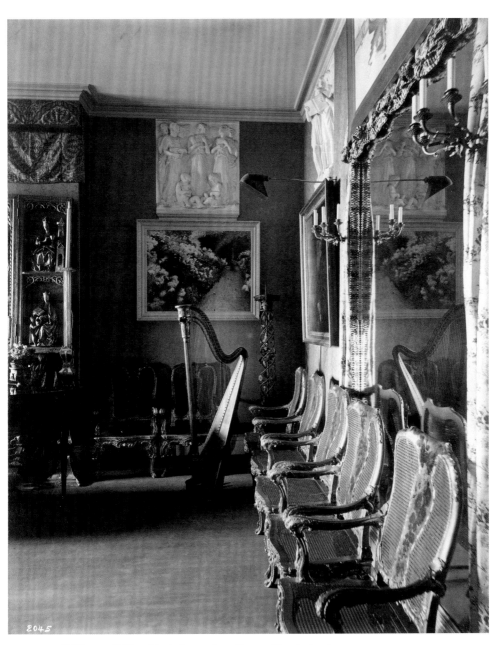

FIG. 38 Thomas E. Marr, Music Room at 152 Beacon Street, about 1900

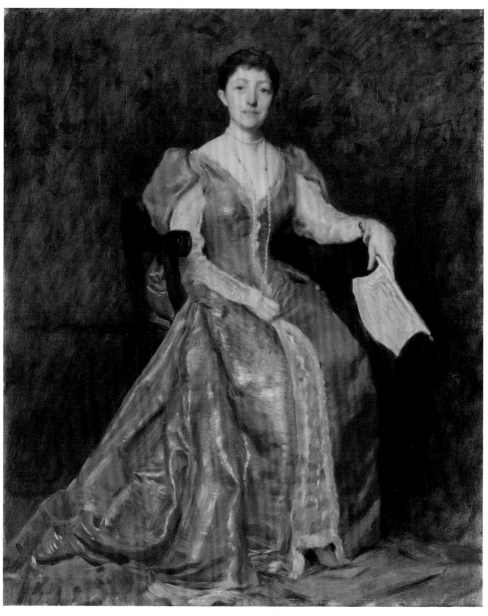

FIG. 39 Dennis Miller Bunker, *Isabella Stewart Gardner*, 1889

biographer Louise Hall Tharp suggested. Then again, there was only
one other Vermeer in the United States at the time, and Isabella may have
appreciated the painting's rarity. Further, seventeenth-century Dutch
paintings generally, if not Vermeer specifically, had begun to attract the
attention of American collectors. New Yorkers and Bostonians esteemed
the Dutch roots of the United States and viewed the realistic portraits,
landscapes, and genre scenes commissioned by a successful merchant
class as reflecting the ideals of America's own princes of commerce.

FIG. 40 Notman Photo Co., Isabella Stewart Gardner and friends in costume at the Boston Art Students' Association ball, April 1889. Collection of the Massachusetts Historical Society

Gardner eventually made additional purchases in this vein, buying several Rembrandts and a painting by Gerard ter Borch.

While works by the famous Rembrandt remained extremely expensive, and Gardner ultimately acquired a small but exceptional group of them, she also began to explore schools of painting less popular in America and therefore less costly. In doing so, she brought her taste for Venice back to Boston, where distance diminished the lagoon city's ruinous condition and history colored the contemporary with a romantic tinge. In April 1889, she had joined a group of friends attending the Boston Art Students' Association ball dressed in a Veronese-inspired gown and with her hair done "à la Tintoretto" (figs. 39, 40). (According to one account, a young Black attendant accompanied her, holding Isabella's skirt, although further details remain unknown.) Long before she possessed the resources to land pricey paintings by these Venetian masters, Gardner was already collecting modest souvenirs of Venice, from glass jugs to velvet textiles and furniture, many purchased from Alessandro Clerlé's antiques shop behind Saint Mark's Square.

Italian Renaissance painting—still uncommon in America at the end of the nineteenth century—was an increasingly popular field of collecting and study in Europe. When, in 1894, Bernard Berenson wrote from London to ask Gardner, "How much do you want a Botticelli?" the painting in question was in an English aristocratic collection, removed from

Italy at least a generation earlier. Precious few Renaissance paintings had reached the United States, with the little enthusiasm for collecting in this field resulting in part from the works' often violent or deeply religious subject matter, and perhaps even from anti-Italian sentiment. Furthermore, almost none of the paintings bore signatures or dates, leaving the question of authenticity to a handful of European experts.

Berenson transformed the study of Italian painting. The post-college trip to Europe that Gardner cosponsored changed his life's direction, revealing his ambition to become a connoisseur—a new form of expert charged with determining the artist and date of a painting from the past. When he offered Gardner a Botticelli in 1894, they had only recently gotten back in touch, following the gift of his most recent publication, *Venetian Painters of the Renaissance* (1894). Pioneering in scope and ambition, this book was the opening salvo in a campaign to catalogue Italian painting for the first time by artist and regional "school." Its series of texts eventually formed part of the bedrock of the study of art history in the United States.

Both Gardner and Berenson saw the opportunities a collaboration would bring. Berenson's specialized expertise and on-the-ground knowledge of the Italian art market put him in a unique position to source and offer first refusal on the masterpieces, above all Italian, flowing out of Europe. Gardner's taste for all things Italian, including the stuff of Christian ritual practice, made her the ideal buyer. Considering her relatively limited means, the modest prices and low demand from other American collectors further enhanced the appeal of the paintings. Between 1894 and 1899, when she broke ground on the Museum, Gardner purchased at least twenty-six paintings and sculptures through Berenson and turned down many more. The successes included America's first paintings by Fra Angelico, Botticelli, Carlo Crivelli, Raphael, and Titian. In addition, she acquired a sculpture by Benvenuto Cellini, the papal goldsmith.

At the same time her business relationships extended beyond Berenson. The painter Ralph Wormeley Curtis jokingly described the friends who sought out artworks for her, including himself, Norton, and the painter Joseph Lindon Smith, as "your gnomes." As records show, Gardner purchased the first painting by Piero della Francesca to reach this country through Berenson's rival, the Florentine art dealer Elia Volpi, and America's debut painting by Andrea Mantegna from Norton's son Richard. Chagrined by the competition, Berenson opined of the Mantegna, "But oh, I do wish you had not bought it without consulting me." Yet it was hardly an exceptional case.

As prices began to rise, Jack Gardner suspected that Berenson was taking advantage of his wife. Isabella wrote her advisor, "*They* say

(there seem to be many) that you have been dishonest in your money dealings with people who have bought pictures. Hearing this Mr. G. instantly makes remarks about the Inghirami Raphael you got for me." In truth, Berenson profited handsomely from Isabella's purchases and sometimes got carried away, as in the case of Raphael's *Tommaso Inghirami*, asking nearly double what the Italian owner sold it to him for, then repeating the strategy for a pair of portraits by Hans Holbein. In addition, for many sales Berenson worked closely with the London-based gallery Colnaghi and Co., a firm Gardner detested, receiving a 5 percent commission from her plus a portion of the gallery's profits. Yet his offers were unprecedented, providing Isabella with first refusal on potential acquisitions for which national museums—the Louvre in Paris, the Gemäldegalerie in Berlin, or the National Gallery in London—were often her competition.

As the American taste for Old Master paintings began to take hold and broaden into new categories like the Renaissance, sales records were set and reset. The director of Berlin's museum simply could not afford Titian's *Rape of Europa*, and Gardner landed it for the record sum of £20,000 (about $3 million today). She broke that record two years later with the country's first great Rubens, *Thomas Howard, Earl of Arundel*, purchased for £21,000. Even heavily restored pictures found buyers quickly. Berenson described the sale of one painting by Paolo Uccello that Gardner had refused: "The George and the Dragon ascribed to Uccello at Bardini's which I would not let you buy for 200 was sold at Christie's last week for 1,420!" Despite her complaints, threats, and the suspicions of her husband, Gardner continued to buy, even increasing the frequency of her purchases in the late 1890s (see Appendix 2).

Gardner did not draw distinctions between art that was purchased legally and that which was not. Some acquisitions followed government regulations, for instance, that of the Farnese Sarcophagus (about AD 225), bought by Jack Gardner through Richard Norton and licensed for export on March 13, 1898, by Italy's Office for the Export of Antiquities and Art (Ufficio Esportazione Oggetti d'Antichità e d'Arte) in Rome. But, as in the case of other museums that grew in that era, it is impossible to know the exact circumstances that brought most objects into the Gardners' collection, not least because Isabella bought through inter-mediaries who often shielded her, and because the Italian government enforced existing laws only intermittently.

At least one of her purchases, however, triggered a rare investigation: that of Botticelli's *Virgin and Child with an Angel*. Sold by Prince Chigi in Rome, through Bernard Berenson acting for Colnaghi and Co. in

London, but never cleared for export from Italy, the painting was the object of a lawsuit against the prince by the Italian state. He was found guilty but later cleared of wrongdoing. The incident became a popular sensation, generating newspaper stories with headlines including "Boston May Lose a Picture: Mrs. Gardner's Botticelli Has Caused Trouble in Italy." In other cases, recent research has revealed suspicious circumstances. For example, Berenson sourced Gardner's *Annunciation* altarpiece by Piermatteo d'Amelia through another art dealer acting on behalf of a group of Franciscan friars in Assisi who had been paying off the state inspector for heritage and culture so that they could sell works of art from their convent that may or may not have belonged to them. Berenson, as was typical, kept the details from Gardner. Customs checks were notoriously lax, but he still sought to avoid any potential trouble by packing the painting in a trunk with a false bottom and covering it with children's dolls.

Gardner was buying at exactly the moment when England, Italy, and other European countries were grappling with evolving ideas of heritage and differing solutions regarding how to preserve it. Her entirely legal purchase of Titian's *Rape of Europa* from an English aristocrat in 1896, for instance, contributed to the outcry over art treasures leaving Britain and to the nascent idea of an English national cultural patrimony, even if the painting in question was made by an Italian artist for a Spanish patron. English law did not change until 1909, while Italian laws responded piecemeal to the ongoing trade in artworks, leaving many gray areas for art dealers to operate in with little fear of serious consequences. Italy, in particular, offered an advantageous situation for opportunistic agents due to its relatively recent unification into a nation and poor enforcement of national laws, among other factors.

Gardner continued to match her enthusiasm for the past with art of the present. In 1893, she met one of John Singer Sargent's most talented contemporaries in the field of portraiture, Swedish painter Anders Zorn, at the World's Columbian Exposition in Chicago. He had come as the curator of the Swedish pavilion, and she bought from him *The Omnibus* (fig. 41), a virtuoso demonstration of his talent in the depiction of a very modern subject—unaccompanied women on public transportation. Zorn later recalled: "She stopped in front of my *Omnibus*, turned to me, pointed at the painting in question. 'I want to have that painting. May I buy it?' 'Yes,' I answered. 'Who is Zorn?' 'I am.' 'Oh, you! I feel that either we will soon become enemies or, forever, very, very good friends. Come to tea with me this afternoon.'" Whatever the truth of

FIG. 41 Anders Zorn, *The Omnibus*, 1892, in the Blue Room

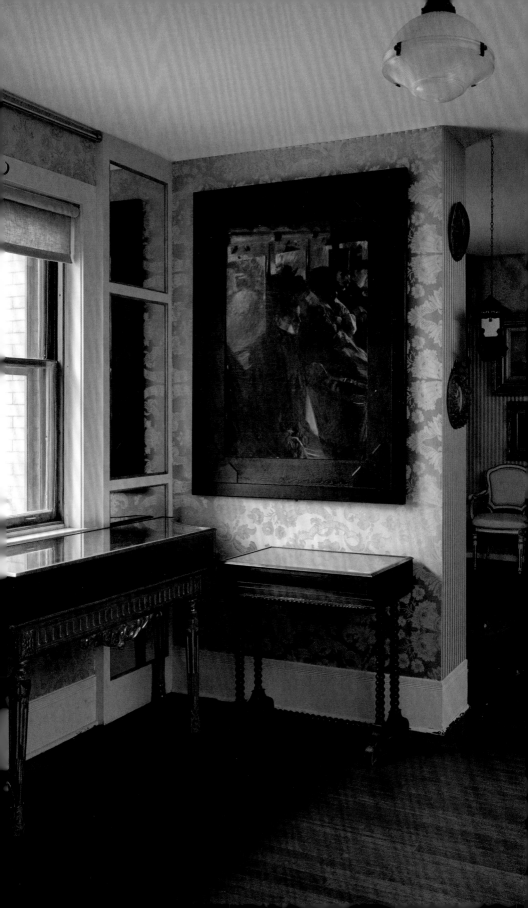

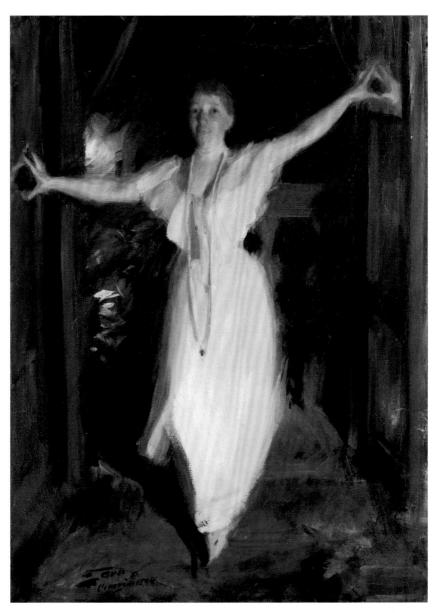

FIG. 42 Anders Zorn, *Isabella Stewart Gardner in Venice*, 1894

this anecdote, Gardner became Zorn's most important American patron, ultimately amassing a collection of the artist's work that included five oil paintings, six drawings, and seventy-eight etchings. His portrait of her envisioned Gardner stepping inside from the balcony of a palace along the Grand Canal (fig. 42). Zorn captured her at her most regal, but not in the sense of the overstuffed American aristocracy. Instead, he realized Gardner as an arbiter of culture who lived larger than life, the kind of figure Gardner's friends imagined when they addressed letters to her as "Dear Queen Isabella."

In addition to supporting prominent male artists of her day, Gardner also acquired works by women artists and authors, including novelist Sarah Orne Jewett, photographer Clover Adams, painter Rosa Bonheur, sculptor Anna Coleman Ladd, painter Elizabeth Wentworth Roberts, and bookbinder and artist Sarah Wyman Whitman. This was somewhat unusual for her time. Major rival Henry Clay Frick, also a museum builder, never deliberately collected works by women. Even important female collectors seem to have acquired few. By 1886, Catherine Lorillard Wolfe, a donor to New York's Metropolitan Museum of Art, had amassed a collection of 148 contemporary paintings, but only four were by women. Yet, while Gardner seized on the opportunity to patronize a limited number of female painters and sculptors, she never explicitly advocated for the role of women in the arts. And the proportion of works by female artists in the Museum remains low, reflecting both Gardner's wide-ranging tastes and long-standing biases in the history of art.

Gardner reinvented 152 Beacon Street with carefully choreographed displays. In 1893, Henry James playfully suggested that her house could be a display at the Columbian Exposition: "Won't there be the Federal buildings, & the states buildings, and then, in a category by itself, Mrs. Jack's building?" Gardner was already arranging altarpieces, portraiture, furniture, and souvenirs into assemblages that resonated with personal and historical meaning, presaging the installations in her Museum. Although such density and diversity of decor were not unusual in Victorian houses, friends consistently singled out the taste with which Gardner realized them. The French writer Marie Thérèse Blanc (penname Thérèse Bentzon) judged, "Everything is in its place, every-thing even a flag which belonged to the grenadiers of Napoleon's guard, which seems to recount the glories of the French army to the corner of a renaissance masterpiece. There is no crowding, no confusion, no show; a masterly harmony pervades the whole; it is simply the exquisite setting for a charming woman."

Gardner made her homes in Boston and Brookline into salons of music, art, and ideas, bringing in friends and notable visitors for

If I do vow a friendship, I'll perform it t

GOING TO	EVENTS
56 Mt. Vernon St.	Here I find
Cambridge	Bright re Lucus a
Boston	Music hath Brooklin
Beauty-	What need
one of them	good friends + lovely music
Boston	

FIG. 43 Isabella Stewart Gardner, *Guest Book, Volume III*, 31 May 1896–02 September 1897, page 29

concerts, lectures, and dinners (fig. 43). She was a vice president of the Orchestral Club of Boston—an amateur orchestra—and a guarantor of the Boston Musical Association, both of which featured male and female musicians. She championed local musicians and international performers, including German-born violinist and composer Charles Martin Loeffler, French pianist and composer Gabriel Fauré, Australian soprano Nellie Melba, and English composer Ethel Smyth, among others. She even purchased exceptional instruments for her favorites, including the Stadavarius violin "Camposelice" for Loeffler and a cello, possibly by Guarneri, for Pablo Casals. The first-floor music room at Beacon Street was big enough for concerts by chamber ensembles and even a medium-sized orchestra.

Just as music set the tone and created an atmosphere distinctive to Isabella, so too did her stories surrounding individual art acquisitions. Playwright Thomas Russell Sullivan recalled a dinner at the Gardners' on March 10, 1896:

> Our hostess showed us her newest treasure which only came this morning, a portrait of Rembrandt, by himself, in a green

velvet doublet with gold chain, a hat and feather. It is a younger Rembrandt than we know—a masterpiece. . . . The owner, dying, left instructions that if it did not bring a stated price within his time-limit, it should pass to the National Gallery. Mrs. Gardner, hearing of this, cabled the money two days before the time expired, and henceforth the Rembrandt will hang in her drawing-room, cheek by jowl with her Van Eyck, her Van der Meer, her Botticelli, her Lippo Lippi, her Lucas Cranach—fine examples all. Her other purchases of this year include a man's portrait by [Giovanni Battista] Moroni, a beautiful seated figure of Mrs. Moodie, the actress, by [English painter George] Romney, and an old man, in a brilliant red robe, of Tintoretto. So, day by day, the wonderful Musée Gardner gains in value.

The stories behind these extraordinary paintings were just as key to Gardner's construction of her identity as the artworks themselves. Through their histories she made the glories of the past reflect upon her present, sparking conversations that conveyed the works' artistic merits to visitors, as well as the difficulty of their acquisition and the distinguished status of their previous owners. She even made Berenson write her a detailed provenance of each picture he sold her so that she could visit their homes abroad, see their prior owners' ancestral collections, and, presumably, compare them with her own.

The year 1896 was a defining moment for her collection in several ways, pushing her toward the idea of a museum. To begin with, an unexpected turn of events consecrated her pioneering taste for the Italian Renaissance with the gain of an iconic painting. That year Berenson had offered her one of the world's most celebrated pictures, the so-called *Blue Boy* by the eighteenth-century English painter Thomas Gainsborough. Beyond its star value, English portraiture was a well-established taste among America's elite collectors and Gardner already owned a George Romney portrait, as well as a watercolor by the English Romantic painter Joseph Mallord William Turner. But when *Blue Boy* was suddenly withdrawn from sale by the owner, Gardner immediately snapped up Titian's *Rape of Europa* instead, forever abandoning British art (several years later, she sold the Romney portrait). Acquiring *Europa* was a coup and meant that her collection was easily museum worthy.

CREATING THE MUSEUM

1896–1903

While she and her friends already called the palatial residence on Beacon Street a museum, the decisive purchases of 1896—including the Titian and the Rembrandt self-portrait—prompted Gardner to take the first steps toward making that impression a reality. She had already discussed the idea for a "gallery" with Berenson, who had insisted in his offer of the Rembrandt that any valid museum must also contain a picture by Venetian Renaissance master Giovanni Bellini. With such encouragement, the plan only continued to evolve.

Gardner lost no time in finding an architect, Willard T. Sears, who had designed a house for her and Jack on Roque Island in 1882. Several days after *Europa*'s arrival in Boston, she met Sears on a train to a wedding in Yarmouth, Massachusetts, and asked him to draw up plans for transforming Beacon Street into a "Museum with living apartments over." Gardner's choice merits some consideration. Notably, she ignored famous architecture firms like McKim, Mead & White, who had worked on major projects like the Boston Public Library and also designed her parents' mausoleum in Brooklyn's Green-Wood Cemetery. Instead, she approached a local man within her family circle. Sears had already worked for her, Jack, and his brother, and, as one scholar has pointed out, Jack valued him for his capable management and experience with large buildings rather than as a brilliant creator. The choice suggests, then, that Isabella herself already had in mind some specific architectural ideas.

Isabella Stewart Gardner on a Ladder during the Construction of Fenway Court, about 1900

The notion that an adapted house provided the best showcase of an owner's art collection was hardly new. Two examples Isabella would have known of were the extraordinary collection of impressionist, post-impressionist, and modernist painting assembled by her acquaintances Bertha and Potter Palmer at Palmer Mansion in Chicago (finished 1885), and Alma Vanderbilt's assemblage of Gothic fine and decorative arts at Marble House in Newport, Rhode Island (completed 1892). These houses featured installations of paintings, sculpture, and decorative arts, but they were never intended to be open to the public. Visits were by invitation only. By contrast, the Gardners' home at 152 Beacon Street was already a destination in its own right. In 1900 Isabella opened it to the public for three days, mounting an exhibition of her collection with an admission charge of twenty-five cents and donating the proceeds to a school for children with disabilities.

A "house museum" designed for public access had little precedent in America. One exception was the home of Baltimore art collector Henry Walters, which in 1874 was already open to the public on occasional days. Another emerging museum type was that of the Cooper Hewitt, founded by sisters Sarah Cooper Hewitt and Eleanor Garnier Hewitt and inaugurated in 1897 on the fourth floor of the Cooper Union school in New York City. The museum, which is still open today in a different location, was intended to "promote industrial art" and design. Gardner's plans set her idea apart from this kind of educational space. She also conspicuously avoided the trend for Beaux-Arts buildings with white-walled galleries, exemplified by Harvard University's Fogg Museum, completed in 1895. The kind of house museum she envisaged was more familiar in Europe, where it recalled the tradition of aristocrats opening their homes to the middle-class public on special visiting days. In the 1850s, Gardner had toured the private Poldi Pezzoli collection, installed by Gian Giacomo Poldi Pezzoli in his palatial mansion in Milan, and commented that she one day hoped to build a house like his. Another likely inspiration was the collection of Richard Wallace, located in London's Hertford House, which Gardner had visited with her friend Elsie de Wolfe, the interior designer, in 1890, and with Berenson in 1897, but which did not open to the general public until 1900. Similarly, the private collection of Édouard André and Nélie Jacquemart, formed in the 1880s and 1890s and housed in their Paris mansion, opened as a public museum in 1913.

Despite these precedents, Gardner subsequently changed her mind. She abandoned plans to transform 152 Beacon Street and embraced the idea of a new, purpose-built museum building. While her rationale remains a mystery, Jack Gardner may have played a key role. According to the later (and not always accurate) recollections of Corinna Lindon

Smith, wife of the painter Joseph Lindon Smith, at a dinner in 1898 the Gardners had discussed building a museum from scratch on an empty lot in Boston's marshy Fenway, in part because Jack worried that Beacon Street's many residential buildings would not allow light on all sides of their museum, and thus detract from the displays. As a savvy real estate investor, Jack was closely familiar with the advantages and disadvantages of different types of Boston residential properties. He could also have been responding to his wife's preoccupation with the lighting of her collection, which had emerged clearly during her installation of Titian's *Europa*: she situated the painting at home near a large window but also called an electrician "to arrange for *Europa*'s adorers, when the sun doesn't shine."

Before any further debate about their museum's location could occur, Jack Gardner passed away suddenly on December 10, 1898, from a stroke. The loss of her lifelong partner was tragic for Isabella. Founder of the Boston Symphony Orchestra Henry Lee Higginson wrote to her of his friendship with Jack:

> No words of mine will tell the loss, which Jack's death brings to us all—& if to us, what must it be to you? Since he was born he has been the same person, & for fifty years I've always known where to find him. Nobody came to our office, who was so universally welcome as he & for good reasons. Just, reasonable, high-minded, kind, affectionate, considerate, intent on doing others a kindness, impulsive & full of careful thought as to his duties & his conduct, wise, honorable to the highest point—gay & charming—such a gentleman with his courteous, cordial manners & yet so independent withal—To me no one will fill his place. . . . T'is no matter tonight what the public has lost, but it is very, very much—And it may please you to know that his last talk with me at 12 o'clock Saturday was from a wish to do a service to others—a fit ending for as true a gentleman, as has ever blessed me with his affectionate friendship & help—I always knew that I could count on Jack for anything decent, & I always desired to do the same by him.

In her grief, Isabella accelerated their pursuit of a museum. On December 30, 1898, just two weeks after his funeral, Isabella surprised Sears with a new plan that followed Jack's advice. According to the architect, she had purchased a lot in Boston's marshy Fenway district and

> wanted me to make new drawings & to include a small theatre with the Museum, the Museum to be one story less in height

than the one drawn for her at 152 Beacon Street. She wanted the drawings to be made as soon as possible so that they could be referred to in her will. She made no reference to the probable cost of the building.

Facing a park laid out by Frederick Law Olmstead, and largely surrounded by undeveloped land jokingly referred to as "the dump," the lot addressed any concerns about light. Gardner's choice was also prescient in staking out Boston's new cultural district. It was the last available lot. In 1902, the Boston Symphony moved in nearby, followed by Harvard Medical School in 1906 and the new Museum of Fine Arts in 1909.

Construction of Gardner's Museum unfolded between 1899 and 1901. As plans took shape, her total financial outlay for art acquisitions climbed. The years between 1896 and 1902 reveal the largest outlays of capital: $205,924 (about $6.5 million today) in 1896, ascending to a high of $381,700 (about $12.3 million today) in 1898, and coming back down to $138,356 in 1902. The high points track the conception, construction, and installation of the Museum, and represent not only the addition of masterpieces to the collection but also elements of the building fabric itself (fig. 44). Some of these structural pieces were antiques, or presumed to be, like the Ca d'Oro balconies that today overlook the Museum's courtyard (although sold to Isabella as Renaissance originals, they were actually fabricated in the nineteenth century). Decisions were often made on the basis of photographs (fig. 45); others she made in person as she continued to travel.

On August 16, 1899, she wrote to Sears from the Palazzo Barbaro in Venice, "I hope to find all the underpinnings [foundations] finished by my return, the end of November probably. But I do not want anything else done, as I want to be present. I shall order here all *pilasters* and *arches* and probably the *staircase*. So do nothing about them, at least until I see you." Not everything came from Venice, and Isabella had fabricated what she could not source. Local stone masons made matches for balconies bought in Venice, while workmen fashioned the crenellation—a signature element of Venetian Gothic palace facades and typically carved from marble—with papier-mâché and wire mesh. Gardner's incorporation of architectural salvage, and some historical replicas, into the building's fabric was another first for an American museum, recalling the home studios of contemporary artists, like those of Joaquin Sorolla y Bastida in Madrid and George Grey Barnard in New York City. This approach laid the groundwork for a particular mode of American architecture that

FIG. 44 Courtyard with architectural elements

FIG. 45 Moise Dalla Torre & Co., Stone Arches, Venice, about 1900

presents history as an immersive, sensory experience. Gardner's creation was later echoed in Hearst Castle in San Simeon, California, and the Cloisters in New York City.

With precipitous walls, elaborate windows, and carved balconies, the building Sears and Gardner created resembles a palace on the Grand Canal. The Venetian flavor was hardly accidental. Beyond Gardner's preference for the city, Norton had advocated for the Venetian Gothic architectural style as a form of moral commonwealth to which Boston should aspire, above all in privately sponsored artistic projects like this one. The new building also recalled Isabella's rented home in Venice, Palazzo Barbaro, which had served as not only residence but also artistic and cultural salon. Yet Gardner did not simply replicate a Venetian palazzo. Rather, she reworked the form's signature features by repurposing its exterior decorations, bringing the outside—windows, balconies, and pinnacles—indoors. Similarly, she dispensed with the utilitarian courtyard, traditionally used by Venetians for storage and services, and transformed it into a living garden bursting with color. Throughout her life, plants were essential to Gardner's creative vision. Her first response to her exposure to Asian cultures had been a "Japanese garden" created at Green Hill in 1883, likely the first such example in America. Twenty years later, in the Museum she arranged flowering plants around sculptures, classical and Egyptian, evoking the elaborate gardens of the palaces of Renaissance Rome. At the same time, she surrounded the courtyard on three sides with a covered walk, recalling the contemplative cloister of a medieval monastery. Through its pink color, her courtyard even evoked Indian architecture that she had seen and admired during her visit to the subcontinent in 1884. In short, Gardner's Museum brought the world to Boston.

Gardner's allusion to medieval devotional architecture suited a collection strong in pre-modern European art. In 1897, she purchased a small bronze cross, becoming America's first collector of Romanesque sculpture (fig. 46). Later she added significantly in this area, buying a monumental limestone sculpture group from the entry portal of Notre-Dame-de-la-Couldre in Parthenay, France, including *Christ Entering Jerusalem* and *Two Elders of the Apocalypse*, and a life-size *Crucified Christ* from a Catalan sculpture group of wood. In addition to these significant Romanesque acquisitions, she bought a window from Soissons Cathedral, today the most important piece of thirteenth-century stained glass in the United States. These and other purchases—both large and small—of medieval sculpture and decorative arts were ahead of their time, setting the tone for contemporary collectors including Henry E. Huntington, Henry Walters, and P. B. Widener, who followed in her footsteps.

FIG. 46 Enamels Case in the Long Gallery with Romanesque Bronze Cross above

Gardner's aesthetic vision of a contemplative environment in which to appreciate art responded in part to Berenson's inspiration. Five months before she broke ground in the Fenway, he had sent her an essay, written together with his wife, Mary, and brother-in-law, Logan Pearsall Smith, titled "Altamura." Essentially outlining a religion of aestheticism, it described an imaginary monastery in Italy (Altamura) with a liturgy of art. Gardner replied gratefully. Consciously or not, her ideas reflected parts of this vision, above all in creating her Museum as a temple of art—a building uniting artistic ingenuity and lived experience in galleries above a cloister-like courtyard encircling a garden. The result was a monument to their shared view of communion with original artworks as a sacred experience. She eventually enhanced the quasi-religious environment of the galleries with paintings set on pedestals and tables flanked by candles, a chapel, and even the addition of a consecrated altar. Indeed, Gardner rejected the encyclopedic museum model. Instead, she believed a semi-spiritual experience sparked by original works of art— rather than a didactic experience governed by chronology, region, and typology—rested at the heart of the ideal museum. This conviction also pulled her into a dispute over the display of reproduction plaster casts at the Museum of Fine Arts, which eventually led to the departure of its director, Edward Robinson.

Constantly under the pressure of public scrutiny, she shrouded her project in secrecy from the outset. Sears recalled that at their very first encounter in 1896, she instructed him to "keep the matter secret from everybody." Construction and installation unfolded under similar terms. Gardner borrowed some fittings from her existing residences—like the Venetian fireplace flanked by heraldic textiles in Green Hill's Venetian Music Room that she repurposed for Fenway Court. Because she worked out her designs and installations by trial and error, she must have known that she was not likely to receive positive treatment in the press until the Museum was complete. Yet the silence prompted wild speculation by journalists, who characterized the Museum as Gardner's "mysterious building." One article claimed that she had bought Florence's grandest palace, the Palazzo Pitti, shipped it to America, and was reconstructing the behemoth brick by brick in Boston. "Weird Wall Shuts Mrs. 'Jack' Gardner's Palace in from the World and Causes Speculation among the Curious Who Watch It Growing," ran another headline in June 1901. Instead of celebrating the new building, the newspaper dismissed it as the "Whim of a Woman," a phrase lifted from the headline of a profile on Gardner in the *New York Journal and Advertiser* (1899). The gossipy tone and dismissive language of this coverage attest to the precarious status of a newly widowed woman in a male environment whose actions often fell outside the boundaries of society's accepted norms.

As a visionary curator rather than a trained architect, Gardner's conviction of taste often collided with the prosaic realities of construction, challenging her relationship with Sears. Photographs reveal that she supervised the installation of architectural salvage, climbed up ladders, and directed activities on-site; this went on to such an extent that Sears advised her to take out accident insurance (Gardner declined). She changed the heights of windows, swapped one color of bricks for another, insisted on wooden beams when steel was the norm, relocated heating ducts, and even "stopped the masons Saturday afternoon . . . had them take down what they had built and build a portion of it at a lower level." The frustration of her architect shines through in his detailed diary entries, which biographers have often drawn from to paint her in a negative light as the proverbial "exasperating woman." Their sexism is manifest. If Gardner had been a man, she would have been characterized by the same biographers as the brilliant and hard-nosed business titan who stood by his beliefs in the face of all challenges. As it was, like most first-time clients working with an architect, she did not always understand the practical implications of her decisions until confronted, and then responded, naturally, with vexation. More to the point, she learned

FIG. 47 Glass Roof of the Courtyard

from mistakes and adapted quickly, ultimately accepting some of Sears's suggestions and never losing her focus on fundamental elements, such as her battle—ultimately successful—for a glass roof enclosing the courtyard, to make her plan for the garden a reality (fig. 47).

During construction, Gardner frequently came into contact with men of lower classes, and she was a familiar presence among the carpenters, bricklayers, and stone masons (fig. 48). Despite attempts to paint Gardner as "of the people" in stories about her taking lunch with the workers, their recorded interactions were often fraught. To cite two examples, she ordered a team to remove scaffoldings against the architect's wishes, and she called the foreman a "thief." Since Gardner did not record any of her own thoughts on these matters and newspaper reporting cannot be trusted, it remains difficult to know the truth.

Names of some of the companies who contracted workmen to build the Gardner Museum survive in Isabella's account ledgers. Little is known of the laborers' specific personal circumstances. Many were Italian and Irish immigrants, although at least one hailed from Japan. They all worked long hours for little pay. Massachusetts adopted a nine-hour workday in 1891, optionally reduced to eight hours in 1899, but only if the majority of voters of the city in question accepted the change. The state, while first to do so, did not enact a minimum wage until 1912, and

then it was only for women and children. Bricklayers, for example, made $3.60 per day on a project where changing the height of a single window cost $300 to $400. Gardner encountered these realities head-on in 1901 when carpenters in Boston went on strike for an eight-hour workday without a reduction in wages. According to newspapers, she received their delegation at home to listen to their grievances. She also met with the building laborers' union, who claimed a middleman was pocketing 50 cents of their $2 per-day wages. Whether she was interested in keeping the status quo or in advancing their cause remains unclear.

Among the site's workers, Teobaldo Travi, nicknamed "Bolgi," stands out. Born in Milan, he immigrated to the United States and, by 1889, was a resident of Dorchester, Massachusetts. An employee of one of her contractors, Gardner chose him to oversee the transport of building materials and historical elements, such as the stylobate lion (a column base from Italy, dating to about 1200) that anchors a corner of the courtyard colonnade. Gardner admired his careful work and later hired

FIG. 48 Construction of Fenway Court, about 1900

FIG. 49 Thomas E. Marr, Teobaldo "Bolgi" Travi in the North Cloister, Fenway Court, 1904

FIG. 50 "The Veronese Policeman," a caricature of Teobaldo
"Bolgi" Travi, the majordomo of the Museum

him on a monthly salary, first as a watchman and later as the Museum's
majordomo. In that role, he ran Gardner's household and oversaw visits to
the Museum, often in an elaborate uniform designed by Joseph Lindon
Smith. In this guise he wore a Napoleonic hat and carried a staff (fig. 49).
Bolgi cut a striking figure. One newspaper eventually published a cari-
cature captioned "The Veronese policeman," satirizing his role as the
guardian of Gardner's Renaissance masterpieces (fig. 50). He worked for
the Museum for forty-one years before retiring in 1940.

 In the midst of the construction, Gardner confirmed the status
of her Museum as a public institution. In December 1900, she obtained
a charter and incorporated the Museum as the Isabella Stewart Gardner
Museum in the Fenway "for the purpose of art education, especially
by the public exhibition of works of art." Repositioning her private col-
lection to work for the public benefit was a task long in the making,
and Gardner had already begun to purchase entire categories of objects,
perhaps to fill in perceived gaps in the visitor experience. For instance,
in 1897 she acquired most of her Christian reliquaries as a gift from her

husband, Jack, and later installed them together in a single case in the Long Gallery (fig. 51). In 1902, she acquired most of the Museum's Old Master drawings at a single auction in London, including sheets by Filippino Lippi, Michelangelo, Raphael, and others. She installed most of them together in the Short Gallery in a single row of cases (fig. 52).

Installation lasted almost two years, nearly as long as it had taken to build the Museum. In December 1901, Isabella moved into the fourth-floor apartment at Fenway Court and celebrated her first Christmas Midnight Mass in the Chapel. Compared to the substantial house on Beacon Street, Gardner's modest new quarters allowed her to reduce household expenses, preserve more money for her collection, and focus attention on the Museum. She sold 152 Beacon Street in 1902 and made her new living quarters as much like her former home as possible by salvaging its doors, fireplaces, and lighting fixtures. As a wealthy woman, she managed a household staff with a housekeeper, maid, and cook, but many of their names and stories are lost to history. Margaret Lamar is an exception. She was Isabella's loyal housekeeper who had emigrated from Ireland in 1870. She began working for the Gardners early in their marriage and moved with Isabella from Beacon Street to Fenway Court. Isabella stipulated that Margaret be allowed to stay in her living quarters at the Museum if she outlived her. Margaret died in 1928, four years after Isabella, and was buried in Saint Joseph's Cemetery in West Roxbury (the Museum paid for the funerary expenses).

As Isabella settled into domestic life in her Museum—with her pet terriers Kitty Wink and Patty Boy—artworks and furniture continued to arrive, both from abroad and from her existing installations at Beacon Street and Green Hill, which included everything from Japanese screens to Venetian furniture. By January 1902, the galleries were complete enough to allow in a journalist, who finally brought her some positive press: "Inside Mrs. J. L. Gardner's Splendid Treasure House." Gardner lavished attention on each room, transforming bare walls into textured backdrops for paintings, sculpture, and furniture and evoking richly furnished domestic spaces. She chose paint as meticulously as she curated paintings. Insisting on a specific blue, she had instructed Berenson to source "a piece of paper [with] the blue colour that [the Florentine art dealer] Bardini has on his walls. I want the exact tint" (fig. 53).

She dispensed with explanatory labels or texts, rejecting the encyclopedic museum model that sought to teach the visiting public about how art fit into neatly divided periods and places. Instead, she mounted installations that create visual relationships between works

FIG. 51 Ecclesiastical Case in the Long Gallery

FIG. 53 Sample of the blue paint used by Florentine art dealer Stefano Bardini, 1900

of art, which in turn reveal thematic, aesthetic, and historical relationships that transcend boundaries of time, place, and style. Few notes survive, with the exception of a list of paintings for the Gothic Room, a space closed to the public during her lifetime, and a sketch she made of the Dutch Room (fig. 54). These remnants suggest a process of trial, error, and experimentation, also borne out in the early photographs of individual rooms by the local photographer Thomas E. Marr. His black-and-white pictures not only provide the earliest official images of her process but also attest to the importance to her of its outcome and her determination to record and preserve her curatorial vision as much as the acquisition of individual works of art.

Several rooms served specific purposes. Gardner situated a concert hall (fig. 55) adjacent to the main courtyard, signaling the importance of music, which had been a lifelong passion. At the far end of the room rose the stage, lined with Flemish tapestries and decorated with a copy of the relief sculptures by Renaissance master Luca della Robbia for the organ of Florence Cathedral. Concerned as much with the hall's performance as its appearance, Gardner paused construction to bring in musicians from the Boston Symphony Orchestra to test its acoustic properties. Seating for one hundred to one hundred and fifty audience members extended back to the door. And at either side of the entrance, galleries served as waiting rooms: the Yellow Room for the men and the Blue Room for the women. In the former, cases lining the walls displayed Isabella's correspondence with famed composers and performers, including Johannes Brahms and Franz Liszt, and plaster casts of Beethoven's face and violinist-composer Charles Martin Loeffler's hand. Above hung a portrait of Loeffler by Sargent and another of the ballerina Joséphine Gaujelin by Edgar Degas (added one year after opening in 1904). Isabella displayed works by her contemporaries in the Blue Room, including Édouard Manet's painting of his mother;

FIG. 52 Prints and Drawings Cabinet in the Short Gallery

FIG. 54 Isabella Stewart Gardner's notes for the installation of the Dutch Room, about 1914

Sargent's painting of the Canadian Rockies, *Yoho Falls*; and Dennis Miller Bunker's *Chrysanthemums*, a painting of Isabella's greenhouses at Green Hill (fig. 56). Isabella also integrated her carefully curated collection of novels, essays, and poetry into her galleries. The bookcase below the Crawford/Chapman Case—one of several in the Museum— contains works by John Jay Chapman, Francis Marion Crawford, Ralph Waldo Emerson, Nathaniel Hawthorne, Sarah Orne Jewett, Okakura Kakuzō, and Celia Thaxter.

In the middle of winter, on January 1, 1903, Gardner opened her
Museum to the public. Between three hundred and four hundred guests
from the cream of Boston society braved the cold and traveled out to the
city's periphery—an area noted for being a landfill— to take part in
the event. Gardner greeted them like a Renaissance sovereign. As the
Boston Symphony Orchestra played the overture to Mozart's *Magic Flute*
in the Music Room, she opened its doors to reveal the glass-roofed
courtyard filled with flowers and green foliage, a defiant gesture in the

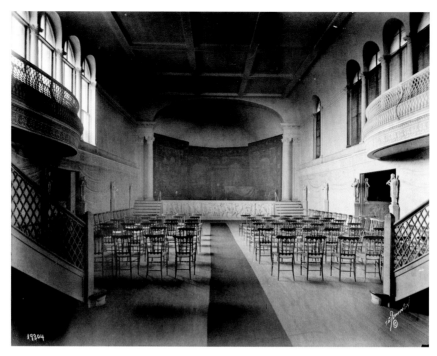

FIG. 55 Thomas E. Marr, Music Room, 1903

middle of the Boston winter. The artworks glistened to the light of a thousand lit candles. Friends were overwhelmed. William James, philosopher and brother of the writer Henry, exclaimed that it was "quite in the line of a Gospel miracle!" His brother later teased Gardner, "Is the Pope going to sell you one of the rooms of the Vatican?" In the aftermath of the opening, Charles Eliot Norton described the heady atmosphere: "Palace and gallery (there is no other word for it) are such an exhibition of the genius of a woman of wealth as never seen before. The building, of which she is the sole architect, is admirably designed. I know of no private collection in Europe which compares with this in the uniform level of the works it contains."

According to legend, only Edith Wharton was underwhelmed by the evening. She disparaged Isabella's choice of refreshments—champagne and donuts—as fit for a provincial French train station. Yet no one else agreed. The opening of Fenway Court, as the Museum was called during her lifetime, was a major event for the city of Boston and for Gardner herself. While Isabella Stewart Gardner was certainly a notable person before the opening of her Museum, the creation of the exceptional institution launched her into a spotlight that endures to this day.

FIG. 56 Blue Room with Dennis Miller Bunker's *Chrysanthemums*, 1888

THE LIFE OF THE MUSEUM

1903–1924

When the Museum opened in 1903, "public" was a relative term.
Starting that spring, Gardner opened the doors to Boston's populace on
the first and third Mondays and following Tuesdays of each month,
which was announced in the local newspapers. By 1910 she had adopted
the semi-regular schedule of two weeks of open days in the fall, around
Thanksgiving, and two in the spring, often coinciding with Easter.
However, even then, the "Fenway Palace," as it was popularly known, was
open only from noon to 3:00 p.m. Tickets were available at Herrick's
Tickets in Copley Square (which also sold tickets to the theater and
opera), and admission cost $1, a considerable sum at a time when a loaf
of bread cost 7 cents. Gardner also limited the number of visitors to a
maximum of two hundred per day. When the Art Department at Harvard
University bought out the tickets for an entire week, Gardner estab-
lished special open days just for Harvard and Radcliffe students. Later
she extended this courtesy to other colleges, including Wellesley
and Mount Holyoke. Gardner herself sometimes took tickets at the
door. Visitors interested to learn more could purchase a small guidebook
(updated annually) for 25 cents, and also prints of the galleries by
photographer Thomas E. Marr.

 Isabella's early experiences of open days led her to believe that the
public, who liked to touch objects in the Museum, posed a danger to
the art. Soon she hired art history students as "guardian-ushers" who

FIG. 57 Thomas E. Marr & Son, Early Italian Room, 1915

supervised visitors as they moved through the galleries. Gardner some-times policed the space directly. Biographer Louise Hall Tharp, who visited as a student in 1918, recalls:

> At the door leading from the Room of Early Italian Paintings into the Raphael Room [fig. 57], I saw a very small woman in black with astoundingly golden hair. Beside her was an ornate gold-leaf table with a marble top and on it was a bowl of yellow orchids, the first I had ever seen. The lady also wore yellow orchids. "Don't touch," she cried out at brief intervals in a voice like a parrot, although we were all walking along a black rubber carpet leading from entrance to exit door with no chance to touch anything. [My friend] Mildred nudged me and whispered, "That's Mrs. Gardner." I looked again and saw that she knew she had been pointed out. Her eyes were like blue icicles as our glances met.

This account—which may explain some of Tharp's biases against Isabella—portrays her as a terrible elitist.

Yet, as with many things related to Gardner, conflicting accounts exist. The Black artist Allan Rohan Crite, who grew up in the Boston

neighborhood of Lower Roxbury, about a twenty minutes' walk from the Museum, visited throughout his life. He was a student at the Children's Art Center in Boston's South End and recalled in an oral history that

> We used to make trips up to the Isabel Stewart/Jack Gardner palace. I remember going there. Of course, the collection they have there is just a blaze of color, the courtyard. I made several drawings. One of them was sent to Mrs. Gardner and she was rather pleased—she was still alive at the time this was before 1924. . . . My mother tells me—she came out with a group of children from the Art Center, and Mrs. Gardner saw her and asked her to come in and sit down and have a cup of tea with her, so she did. That's one of those little pleasant incidents— sitting and having tea with this rather fabulous woman. . . . But, at any rate, it was my introduction to the place. And, as I said before, I just remember this blaze of glory, of color, of flowers and the streaming down in the courtyard; and then of course the mysterious nooks and corners, with bits of Italian paintings and carvings.

Clearly, in her relations with the public who came to visit her Museum, Gardner could be a contradictory character. Her biographers have tried to define her, but she, like most, was never one thing to all people.

The United States government, for its part, did not care about the tenor of Gardner's personal interactions with the public in her Museum— the authorities insisted that nonprofits take seriously their commitment to public accessibility. In addition, the United States had imposed a 20 percent tariff on imported works of art, one reason why J. P. Morgan kept his collection in London. Gardner viewed her purchases as exempt because the Museum was a charitable organization for the public. However, in 1904, the Treasury Department ruled against her, fining Gardner $200,000 on her collection. Opening the doors only a handful of weeks per year did not rise to the government's definition of an organization for the public benefit. Gardner's desire to continue building the collection clashed with importation laws even as she scaled back her other expenses and stopped traveling abroad. In 1908, she was cited again for falsely declaring the value of an imported painting to customs and made to pay the actual duty plus a fine. The work in question was *Hercules* by Piero della Francesca, a prized fresco of about 1470.

Fenway Court opened at the dawn of the twentieth century. Isabella, who was already in her early sixties when she created the Museum, had lived through decades of enormous social upheaval and

economic change. She had witnessed the Industrial Revolution, the American Civil War, the end of slavery, the westward expansion of the United States and consequent displacement of Native Americans, the growth of global empires, and the integration of the world economy. Industrialization and globalization directly facilitated her ability to travel widely and collect art. The world in 1903 was, in short, very different from what it had been at her birth in 1840—and Gardner's life was shaped by these changes.

In the years after the Museum opened, American social norms and political positions shifted. The fight for women's suffrage culminated in the passage of the Nineteenth Amendment in 1919, and Progressive Era social activism linked to causes like labor protection and poverty alleviation gained steam. These efforts coincided with widespread debate about immigration to the United States, and some of the most restrictive immigration laws in the country's history were passed during this time. In 1914, World War I broke out, with the United States entering the conflict in 1917. At the end of the war, the Spanish flu pandemic spread worldwide.

During this period, Gardner was making so many changes to her Museum that scant, and sometimes conflicting, evidence survives of her reactions to the changing social landscape. We can, however,

gain some insights from the ways in which she expanded and used her new Museum.

Gardner increasingly began to collect major works of Asian art. Between 1901 and 1903, she acquired more Asian art than at any other time, probably to fill out the Museum's "Chinese Room"—a term borrowed from European tradition to indicate a gallery for objects not only from China but from East Asia more generally (fig. 58). Among one hundred and fifty objects acquired from the Yamanaka and Bunkio galleries in Boston were architectural elements, wooden furniture, screens, and a large lacquer table. Later Gardner was influenced by Okakura Kakuzō, a scholar and advocate of Japanese culture who moved to the United States in 1904 to take up the role of curator at the Museum of Fine Arts, Boston, but these purchases predate their friendship. The objects echo the taste for Japanese and Chinese patterns and decorative arts shared by other Bostonians in her circle, such as Gretchen Osgood Warren, who displayed her collection in her home. They included, however, an exquisite ceramic incense burner from the Asian art collector and surgeon William Sturgis Bigelow, and at least one outstanding group purchase made in 1902: four sixteenth- and seventeenth-century bronze sculptures of the Buddha, a twenty-four-handed statue of Guanyin, and a god of war acquired from Yamanaka Sadajirō, owner of the above-mentioned gallery, on Bigelow's recommendation. These acquisitions paved the way for Gardner's pioneering purchases of Chinese antiquities several years later.

Berenson also pushed Gardner to buy Asian works selectively, and to create a collection of Chinese art as historically important as her Italian one. Gardner emphasized that she wanted "Old Chinese" art. He sourced for her an exquisitely carved Wei dynasty *Votive Stele* (see fig. 65), which surpassed in artistic merit similar sculptures that Okakura acquired for the Museum of Fine Arts, plus a pair of Han dynasty bronze mat weights in the shape of bears. They were later joined by a twelfth-century seated *Guanyin* in wood, acquired in 1919 and recognized today as the earliest of this type brought to the United States. These sculptures, together with the bronze *Bears* and a Shang dynasty bronze vessel (stolen in 1990), remain some of the earliest Chinese antiquities to come to America, revealing yet another facet of Gardner's forward-looking taste.

Despite Gardner's close friendship with Okakura and obvious appreciation of Chinese masterpieces, some of her views relating to Asian culture remained rooted in common prejudices. In 1905, she transformed the Music Room into a Japanese village "experience," by having a shrine, tea house, and shops built by Japanese workers and selling

FIG. 58 Chinese Room, 1903

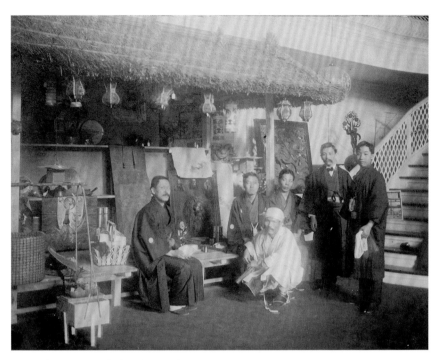

FIG. 59 Japanese Festival at Fenway Court

tickets for the benefit of the tuberculosis hospital (fig. 59). She described the process to Berenson as follows: "It took a whole month for the Japs to make the little village in my Music Room. But such neat, able, delightful little workmen!" Gardner likely did not consider this statement derogatory, since casually racist language was hardly unusual for individuals of her class, but she does not appear to have used such words with Okakura in their correspondence, and it sits awkwardly with her love of Japanese art and culture.

Use of racial slurs like these also runs counter to Isabella's friendships with advocates for liberal immigration laws, notably the Harvard economics professor and politician A. Piatt Andrew, whom she met in 1903. Andrew was a leading member of "Dabsville," a small group of artists and intellectuals who lived on Eastern Point in Gloucester, Massachusetts. (The name was based on an acronym composed of the initials of some of the group's members.) Gardner was a frequent visitor as well as an honorary member of the group. It was a lively place, with regular parties. On the surface, these social events seem no different from other upper-class coastal gatherings of the time; yet Dabsville provided an important retreat for those deemed "other" by social norms. Many of the residents—who included painter Cecilia Beaux and interior designer Henry Davis Sleeper—and their guests

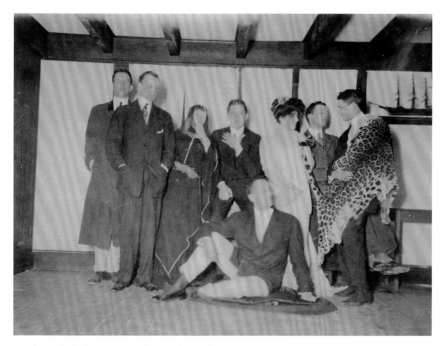

FIG. 60 Isabella Stewart Gardner and Friends at a Party at A. Piatt Andrew's Home Red Roof, 1909

were single, never married, and would be categorized today as gay or queer. Photographs offer a glimpse of their social life, including frequent costume parties (fig. 60).

As noted above, Andrew held progressive views on immigration. He became involved in politics in about 1908, as part of a banking reform task force, and went on to lead the U.S. Mint and serve as an assistant secretary of the treasury from 1910 to 1912. He would later serve as a congressman from Massachusetts, holding office from 1921 until his death in 1936. As part of his growing political career, he made his views on immigration clear. In an article published in the *North American Review* in 1914, for instance, he argued in favor of immigration on both economic and cultural grounds—including citing immigrants' patronage of cultural institutions like museums and libraries.

These positions directly opposed the immigration policies supported by Henry Cabot Lodge, the longtime senator from Massachusetts who also happened to be the father-in-law of Isabella's nephew Augustus "Gussy" Gardner. Gussy was elected to Congress in 1902. While publicly supporting many of the views of his father-in-law, he resisted a primary challenge from Andrew in 1913. Gardner's support for the more progressive Andrew over her own nephew, whom she had raised since childhood, caused a family rift.

STON GLOBE—MONDAY, AUGUST 21, 1905.

MRS JOHN L. GARDNER HOSTESS IN A NOVEL ROLE.

She Awards Money Prizes for the Best Gardens Grown in the Tenement Districts—Poor People Guests at Her Magnificent Home.

MR LEANDRO'S GARDEN
1 V PRIZE NORTH END

MRS O'BRIEN'S GARDEN
2 ND PRIZE NORTH END

A CORNER IN
C J WADDIE JR'S
GARDEN
1 V PRIZE
SOUTH END

JAMES FOLEY'S GARDEN
1 V PRIZE WEST END

SOME OF THE TENEMENT HOUSE GARDENS THAT WON PRIZES
OFFERED BY MRS JOHN L. GARDNER.

It is doubtful if Mrs John L. Gardner ever played more charmingly the role of hostess than she did yesterday afternoon at Green Hill, her beautiful estate in Brookline, to a party of guests representing the North, West and South Ends, who were escorted thither by Meyer Bloomfield of the Civic Service house on Salem st.

Everybody was delighted with the occasion, and none more so than Mrs Gardner, who showed most cordial hospitality to each guest, a number of whom she recognized at once as having met them before at their homes on thoroughfares that are far remote from the fashionable quarter of Boston.

The affair was the outcome of the interest which Mrs Gardner has shown in the social work that is being done by Mr Bloomfield. Early in the summer she offered $100 in prizes for the best results in tenement window and other ornamentation by means of plants, vines and flowers. Yesterday afternoon the winners were awarded the prizes in crisp one dollar bills, which were contained in long envelopes bearing their names, and handed to them by Mr Bloomfield, while Mrs Gardner smiled and applauded as the successful ones received their awards.

Novel in All Respects.

The occasion was in all respects a novel one. About 2:30 a special car left the foot of Hanover st, containing the winners from the North End, their families and the settlement workers of that district. Arriving at the North station it took aboard another contingent from the West End, and at the corner of Broadway and Washington sts it was boarded by the balance of the party, numbering 70 in all, the two latter districts being represented in the same way as was the North End.

The car then proceeded directly to Green hill, where Mrs Gardner awaited her guests in company with George Proctor and several friends. She was simply gowned in white crepe de chine, and wore a lavender hat with a white veil.

It was on the lawn adjacent to the famous Italian gardens that these men, women and children from homes which were the antithesis of this lovely estate, caught their first impression of its beauties. Everybody was invited to sit on the grass in true picnic fashion, while

they did in semicircle form. Then Mr Bloomfield made a brief speech of welcome, in which he said that Mrs Gardner hoped to continue the prizes another year.

At its close he handed to the successful competitors the awards which they had won. There were 18 prizes distributed in amounts varying from $2 to $10, and they were given out to young and old, the winners representing five nationalities.

Some Touching Stories.

Many of these prizes had pathetic stories connected with them, a fact which was known to no one better than it was to Mrs Gardner.

Last Thursday, in company with Mr Bloomfield, she visited a number of the gardens which had been cultivated by the competitors, selecting Salem and Leverett sts as the scene of her visitation. Her interest was so great in what she saw that she did not consider obstacles and even consented to climb to the roofs of some of the houses rather than to miss viewing the gardens.

So when little Margaret McGaffigan was handed an envelope containing $2 she understood the difficulties under which the child had labored to win her award. She could picture in her mind the steep roof where only one window box was hung, which Margaret reached twice a day by means of a ladder for the purpose of watering her treasures. She realized, too, what the dirty back yard was like which Mr Leandro had transformed in appearance from a receptacle where garbage and refuse was thrown into a garden where flowers grew and where pigeons thrived in a cote. She understood how he must have labored to have won the first prize of $10 which was awarded to the North End district.

Then there was James Foley's garden at 26 South Russell st, which contained only a few sunflowers, but they had been grown under such difficulties that he was awarded the first prize of $10 for the West End; and the pathetic little garden of Rose Small, who lives at 14 Leverett st, and who was given the third prize of $6.

Each of these latter gardens Mrs Gardner had visited and she was astounded at what she witnessed.

When the prizes had been awarded light refreshments were served to the company by Mrs Gardner and Mr Proctor, after which they were shown the Italian gardens by their hostess, who explained many things about their wonderful beauty.

At 5 o'clock the special car was in waiting for the party, and with many expressions of gratitude for the pleasure which she had afforded them they bade adieu to Mrs Gardner and returned to their homes.

The winners in the prize contest were as follows:

North End—First, $10, Mr Leandro, 13 Hanover st; second, $8, Mrs O'Brien, 521 Commercial st; third, $6, Eva Koslowsky; fourth, $5, Rebecca Heyman, 50 Salem st; fifth, $2, Mamie Crove, 36 North Bennet st; sixth, $2, Margaret McGaffigan, 4 Buttrick st.

West End—First prize, $10, James Foley, 26 South Russell st; second, $8, Peter Pasquale, 35 South Margin st; third, $6, Rose Small, 14 Leverett st; fourth, $5, Rebecca Umans, 18 Auburn st; fifth, $2, Ellen Prendible, 2 Auburn st; sixth, $2, Esther Feldman, 113 Brighton st.

South End—First, $10, Cornelius J. Waddle Jr, 13 Bradford st; second, $8, Mrs Joseph Burk, 82 East Dedham st; third, $6, Fred Jeffs, 182 Harrison av; fourth, $5, Minnie Davis, 58 Compton st; fifth, $2, Frank Corrigan, 28 West Ded-

ham st; sixth, $2, George Gillespie, 82 East Canton st.

Its Helpful Influence.

Mr Bloomfield stated that the influence of this prize competition had been marked over the people in the congested tenement district. In all there were 100 competitors, and from Charlestown, East Boston, and several other sections many pathetic letters had been received in which the writers had asked permission to share in the contest. Its educational influence had been felt in some of the gloomiest homes in this city where many a dark alley had been brightened by the presence of flowers which had hitherto been unknown to it.

Those in charge of the contest were: Meyer Bloomfield chairman; committee for the North End, Mrs Zelda Brown, social service house, 37 North Bennet st; Miss Gilman, associated charities, Hull st; Meyer Bloomfield, Civic Service house, 111 Salem st; committee for the West End, Miss Goldie Bamber, Hebrew industrial school, 17 Allen st; Miss Caroline F. Brown, Elizabeth Peabody house, Poplar st, corner of Brighton; Miss Caroline M. Caswell, Frances E. Willard settlement, 24 South Russell st; committee for the South End, Miss Ellen W. Coolidge, Ellis Memorial, South Bay union, Harrison av; Miss Mackintosh, Denison house, Tyler st;

This family drama aside, Isabella's support of a pro-immigration candidate resonated with some of her charitable activities. Notably, she worked for years with Meyer Bloomfield, a Romanian Jewish lawyer who advocated for vocational training for immigrants and working-class people. They collaborated to create and fund prizes for an urban gardening contest for the West, North, and South Ends of Boston (fig. 61). At the time, these areas were designated the "Tenement Districts" of the city and were increasingly home to crowded immigrant communities from Eastern Europe, Italy, and Ireland. As in many cities that were swept up in the urban planning wave of the 1890s and 1900s called the City Beautiful movement, in Boston committees were formed to create green space and beautify the neighborhoods. Bloomfield, who aimed to help working-class people find jobs that best fit their skills and interests, saw the gardening contest as an opportunity both for beautification and for residents to learn about plant life and careers as gardeners. Isabella, herself an experienced horticulturist, was an enthusiastic partner. She supplied the prizes—offering $100 (about $3,000 today), to be divided into sums for eighteen people, as well as a visit to her own extensive gardens at Green Hill. In 1905, fifty people vied for the Gardner prizes, and by 1911 more than three hundred gardeners entered the race, with the winners representing five nationalities and a range of ages.

Gardner's opinions on another major political issue—suffrage— are also opaque. Though she was close friends with the devoted social activist Julia Ward Howe—author of "The Battle Hymn of the Republic"— who fought for women's suffrage for more than forty years, there is no clear record of how Gardner felt about the movement to allow women to vote. While she lived to see the Nineteenth Amendment ratified, she was already seriously ill and incapacitated and does not seem to have used her voting right once it was available. Limited documentation reveals her opinions, biases, and behaviors in the face of new challenges and questions that both she and her newly created Museum would have to confront.

Her use of Fenway Court as a space for hosting public and private events, however, sheds some light on Isabella's views about the society changing around her. The Museum, as had her other residences, became an inspiration to artists and a venue for creative performances and intellectual pursuits. Shortly after it opened, John Singer Sargent stayed in the first-floor guest room (now the Macknight Room) and painted five portraits in the galleries—becoming the Museum's first artist-in-residence (fig. 62). Soon Isabella invited musicians, dancers, actors, and authors to perform—often at philanthropic events. Avant-garde dancer Ruth St. Denis performed "The Cobra" in the Music Room to benefit the

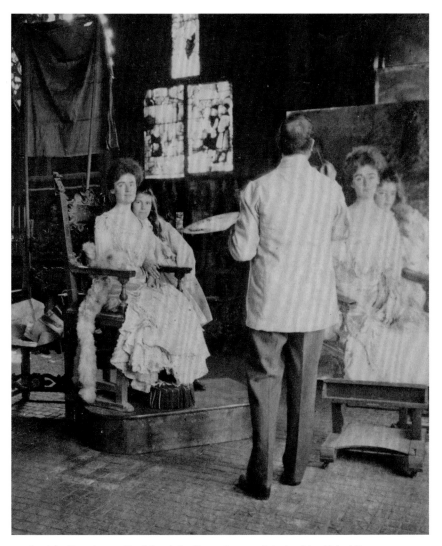

FIG. 62 John Templeman Coolidge, John Singer Sargent Painting Mrs. Fiske Warren (Gretchen Osgood) and Her Daughter Rachel in the Gothic Room, 1903

Holy Ghost Hospital for the Incurables in Cambridge. Actors performed a play in the Gothic Room in 1908 to support the victims of the Messina, Italy, earthquake. Lady Gregory—one of the founders of the Irish National Theatre Society—gave a lecture on national theater and censorship. As Gardner raised money for disaster relief, people with disabilities, and child welfare agencies, she supported her creative friends and memorialized them in the Museum (see fig. 64).

Isabella's interests extended to African American music, and she invited the Boston-based Black tenor Roland Hayes to perform at the Museum. She was a fan of and advocate for *The Red Moon*, a production

by Black musical duo Bob Cole and J. Rosamond Johnson that subverted and challenged the racist tropes typical of minstrelsy (fig. 63). To the Australian American Percy Grainger, Gardner wrote, "I am looking forward to the arrival of the Negro choruses. You are very kind to remember I cared about that music." Her painter friend Sargent introduced Isabella to the wealthy white couple Gerald and Sara Murphy, who sang African American spirituals in the Tapestry Room. As was to be expected, the concert arrangements were far removed from the songs' origins in terms of race, class, and experience. Sargent had advised Isabella that the Murphys' "voices are quite small and it is rather a *sotto voce* performance, so you ought to sit on top of them." Isabella's reaction to their singing is not known; however, she kept a book of African American folk songs given to her by the Murphys in one of the Museum's galleries.

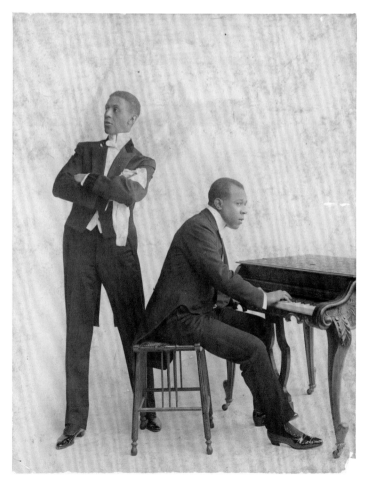

FIG. 63 Bob Cole and J. Rosamund Johnson, 1909

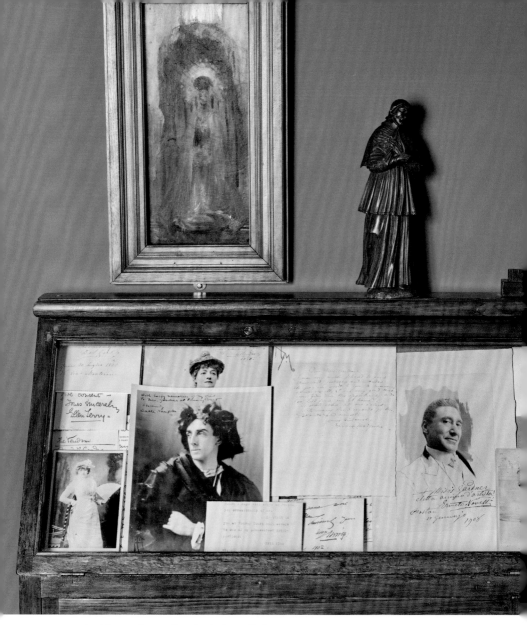

FIG. 64 Modern Actors Case in the Long Gallery

Isabella also supported a handful of charities and civic projects related to the African American community in Boston. She helped to fund the construction of an Anglican church, Saint Augustine's, affiliated with the Society of Saint John the Evangelist (SSJE), an Anglican Episcopal monastic order that ministered to the African American community. The church would be the site of the ordination of the first Black Anglican priest in North America. The order also established Saint Augustine's Home, known as the Foxboro Home for Colored Children, for Black orphans. In 1919, Isabella donated $5,000 to this home and other initia-

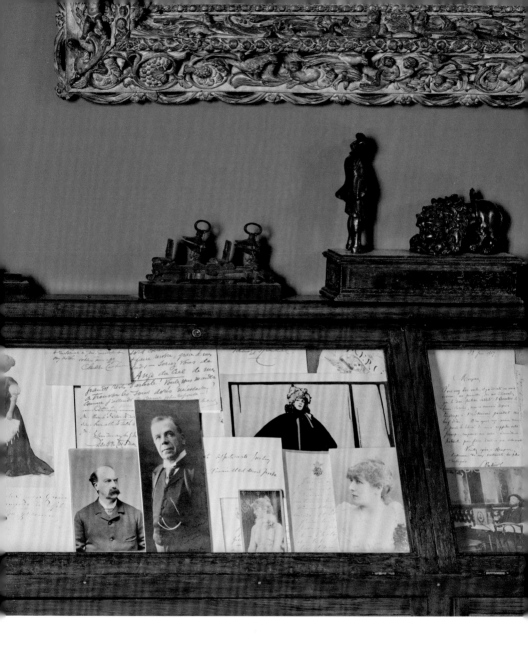

tives spearheaded by SSJE and its sister organization, the Order of
Saint Anne. However, it is clear that among all of these charitable and
civic activities, Isabella viewed the Museum as her most significant
contribution to the community.

Throughout these years, the Museum remained Gardner's princi-
pal occupation. Following a final concert on February 4, 1914, construc-
tion was begun on the ground floor to transform the Music Room into
additional gallery space. Gardner added the Chinese Room, Chinese
Loggia, Spanish Cloister, and Spanish Chapel. On the floor above, she

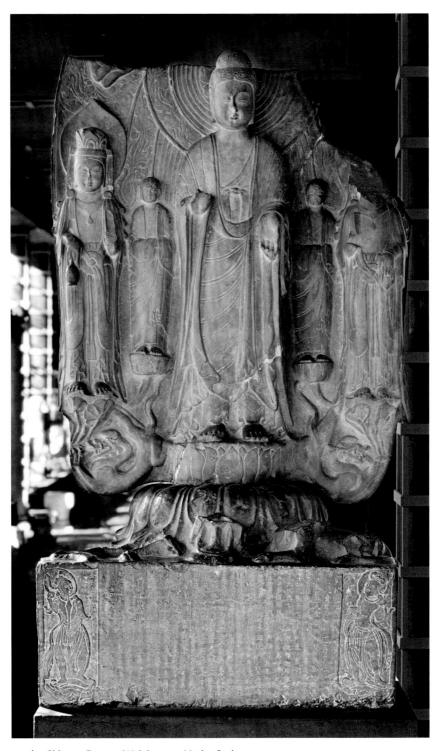

FIG. 65 Chinese, Eastern Wei dynasty, *Votive Stele*, 543

created a single gallery recalling a medieval hall. Running the length of the building, the Tapestry Room showcases her tapestries, Spanish Renaissance paintings, and Persian manuscript miniatures.

Gardner's close friendship with Okakura Kakuzō, who died in 1913, was manifest in these changes. Having created the Chinese Room, she moved it from the second floor into a larger, below-ground space. The new arrangement also coincided with Berenson's encouraging her to buy more Chinese art. Gardner sought to create the impression of a working Buddhist temple of the kind that had enchanted her in Asia. She wrote to Maud Howe Elliott from Japan, "When I get into one I never want to come away. I could lie on the mats and look forever through the dim light." In Boston, she created a similarly heady and intense atmosphere, one which she heightened for visitors by providing lantern tours to enhance the sensation of wonder.

The city's mayor, James Michael Curley, was so affected by his experience visiting the room that he described Gardner as "courageous" for daring to enter it alone. For Isabella, it evoked places she had visited in 1883 and 1884, including China, Japan, and Cambodia, and allowed her to indulge in what she and other Western travelers of the day perceived as the exoticism of Eastern cultures. During this period, Gardner also created the Chinese Loggia, which features her trend-setting purchases of early Chinese art: the *Guanyin* and the Wei dynasty *Votive Stele* (fig. 65).

Relocating the Chinese Room from the Museum's second floor allowed Gardner to accommodate her expanded collection of Italian Renaissance and gold-ground paintings, establishing the Room of Early Italian Paintings (Early Renaissance) beside the Raphael Room (High Renaissance). In addition, it opened up new spaces in which she could celebrate Spanish art. Spain, with its many cultures and religions—Christianity, Judaism, and Islam—and its former colonies, had been a long-term fascination. Over her lifetime, Gardner visited several Spanish-speaking countries and shared her interest with contemporaries, including John Singer Sargent, who loved Spain and visited eight times. Even before renovations began, her Spanish art collection impressed America's most dedicated Hispanophile, Archer M. Huntington. He had founded the Hispanic Society in New York, and following his visit to Fenway Court in 1911, invited Gardner to join its board of trustees, making her the first female member. Gardner prominently displayed her Hispanic Society membership and medal in the President and Statesmen Case on the Museum's third floor.

Gardner already owned important Spanish paintings, including the Velazquez portrait *King Philip IV of Spain*, a rare portrait by Francisco de Zurbarán, and a painting by Zurbarán and his workshop, *The Virgin*

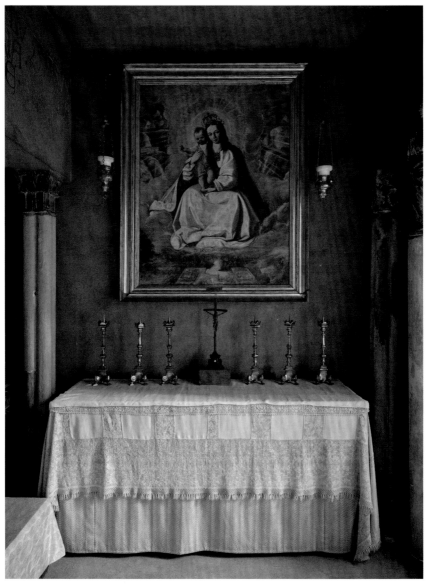

FIG. 66 Spanish Chapel with the workshop of Francisco de Zurbarán's *Virgin of Mercy*, about 1640

of Mercy, which became the altarpiece for her Spanish Chapel (fig. 66), installed beside a tomb figure of a Spanish knight carved in alabaster. As Italian paintings climbed out of her price range, Gardner also began to venture into the lesser known—and less costly—field of Spanish Renaissance painting, acquiring a triptych by Aragonese royal painter Francesc Comes in 1901 and bringing the first work by Bartolomé Bermejo to this country in 1904. To that group, she added an altarpiece

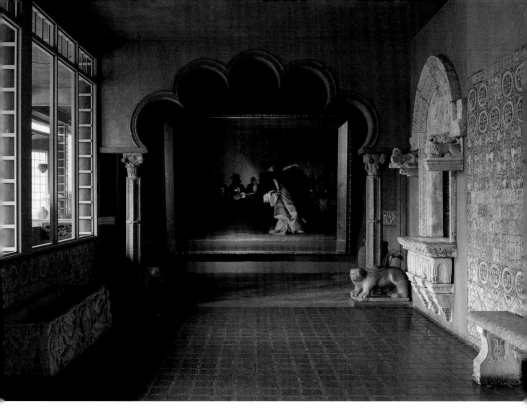

FIG. 67 Spanish Cloister with John Singer Sargent's *El Jaleo*, 1882

fragment by Pedro García de Benabarre to hang over the Tapestry Room fireplace.

For Gardner as for Huntington, the former colonies were as important to her conception of Spanish culture as the mother country. Three wooden relief sculptures from Panama City's cathedral decorate the Chapel. In the new Spanish Cloister, Gardner installed a group of colorful Talavera tiles produced in the Puebla region of Mexico that blend indigenous Mexican imagery with colonial Spanish techniques. Purchased in 1909 from the painter Dodge Macknight, who acquired them from a priest at the Church of San Agustìn in Atlixco, they recall Gardner's own brief visit to Mexico in 1881 and evoke the intersection of cultures at the root of Spanish colonial art—also referenced by the Spanish Cloister's Moorish arch and Islamic tile. Gardner lavished hours on arranging the more than two thousand Talavera tiles.

Beneath the arch, Gardner installed Sargent's acclaimed 1882 Paris Salon sensation, *El Jaleo* (fig. 67). This iconic painting of a flamenco dancer mid-performance, accompanied by her guitarist and a small audience of men and women, captured the two friends' shared love of Spanish culture and music (they traded flamenco records), and attested to their lifelong bond. According to legend, Gardner invited the owner, T. Jefferson Coolidge, her husband's friend, to the newly built Spanish

FIG. 68 An American Field Service ambulance sponsored by Isabella Stewart Gardner during World War I, 1916

Cloister and convinced him to donate the painting on the spot. In fact, even though Coolidge had sent the painting to the Museum of Fine Arts on temporary loan, he had long intended it to go to Isabella upon his death, but moved up the gift, in part due to her arrangement of such a remarkable setting.

In March 1915, Gardner reopened Fenway Court to adoring crowds. Two years of construction and installation had created pent-up demand, and more than two hundred visitors flocked to see it on the first day. According to the newspapers, the Spanish Cloister and the tapestries attracted the most attention, together with the perennial favorite, the garden courtyard. Gardner's Dabsville friend Henry Davis Sleeper wrote to A. Piatt Andrew that Fenway Court "looks better than ever." The *Boston Sunday Post* ran a picture spread highlighting its "many new artistic treasures" with photographs of the Han *Bears* and the fourteenth-century French fireplace in the new Tapestry Room, said to have belonged to Francis I.

FIG. 69 Henry Davis Sleeper and Phipps, Ball & Burnham, Fragments from Reims Cathedral, 18th-century glass, 1919 panel

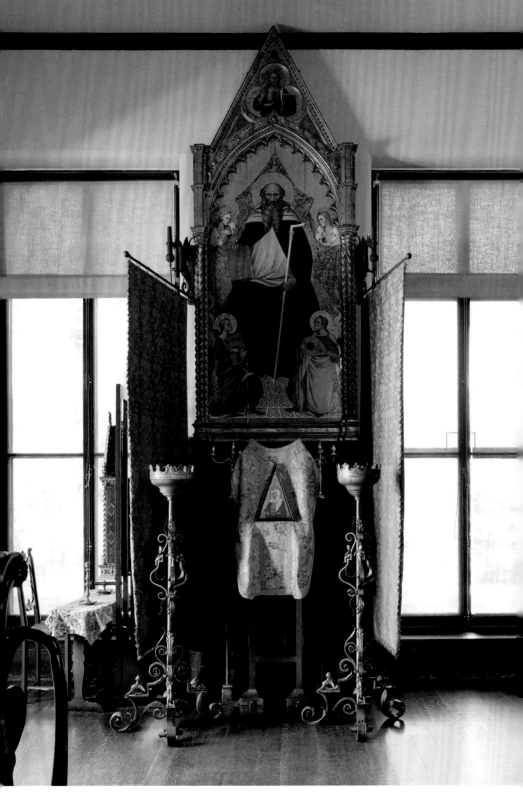

FIG. 70 Early Italian Room with Ambrogio Lorenzetti's *Saint Elizabeth of Hungary*, about 1319–1347

If Isabella's adult life began with one violent and momentous event—the American Civil War—her life drew to a close during another horrific and transformative war: the First World War. Though fighting broke out in Europe in 1914, the United States did not enter the conflict for another three years. Nonetheless, groups of Americans immediately began working to aid the Allied powers, led by France and the United Kingdom, against the Central Powers, led by Germany and Austria-Hungary. Andrew was one of the most engaged volunteers, and Gardner actively supported her friend. Americans were not allowed to fight on the frontlines, but they could assist soldiers with supplies and medical care, which is what Andrew focused on. Shortly after his arrival in France, he founded the American Field Service (AFS) and worked as an ambulance driver. The charitable organization funded and ran ambulances to transport injured soldiers and civilians to hospitals. Gardner was among the private donors who supported the effort, and even sponsored an ambulance named "Y" after her nickname "Ysabel," a reference to Isabella I of Spain and used by Andrew and her other Gloucester friends (fig. 68). One ambulance driver gathered fragments of stained glass from the German bombardment of Reims cathedral. Henry Davis Sleeper had them set into a panel for Isabella, which she displayed in the Chinese Loggia in remembrance of the Great War (fig. 69).

Andrew was not the only one of Gardner's friends involved with and affected by the war effort. Boston Symphony Orchestra musical director Karl Muck, a German-born Swiss citizen, was thrust into the center of controversy during World War I, when he initially failed to include "The Star-Spangled Banner" during performances. The press questioned his national loyalties, and when public pressure forced the conductor to lead the symphony in playing the anthem, Isabella stood up and left the hall in protest. Muck was arrested in March 1918 and imprisoned at Fort Oglethorpe in Georgia until he was deported with his wife one year later. Outraged, Gardner expressed her support for the Mucks as anti-German sentiment grew in Boston. She displayed photographs and correspondence from Muck in the Musicians Case in the Yellow Room.

The war also shaped her art collection. In 1917, the writer and poet John Jay Chapman and his wife, Elizabeth, donated part of a fourteenth-century Italian gold-ground altarpiece featuring Saint Elizabeth of Hungary. The gift honored their son Victor, who was the first American pilot killed in the conflict. Gardner made the small painting the centerpiece of a memorial-like installation in the newly created Room of Early Italian Paintings (fig. 70). Another of Isabella's friends, the sculptor Anna Coleman Ladd—one of the few women artists represented in the

Museum's collection—traveled to France after the war to help make prosthetics for soldiers with severe facial injuries. A letter she wrote to Isabella sums up the horror of the conflict and, possibly, the Spanish flu pandemic that quickly followed the end of the war:

> I want to see you; I know that you have been ill; but I also
> know that you are more wonderful than before. As for me,
> I am quite "unsuccessful" . . . [but] I have done better work
> than ever in my life before . . . absolutely uncompromising
> sculpture, as I saw it; the search for beauty and austerity
> of line . . . expressing a need of the soul; or its combats; and
> the love of youth, in all its forms—youth, which has been
> nearly swept away in the late hellish upheaval.

Ladd's letter not only includes the poignant statement about youth being "swept away in the late hellish upheaval," but also hints at the struggles Isabella was facing at this time by mentioning, "I know that you have been ill."

Gardner had suffered a serious stroke. Morris Carter, who at this point was in regular contact with Gardner as her personal secretary, describes what happened the day after Christmas in 1919:

> After she got home and had gone to bed, she was taken ill, and
> from that illness she never recovered. Her right side was para-
> lyzed, but as long as there was any hope of recovering her
> strength and regaining her activity she invented explanations of
> what might prove a temporary disability—it was the grippe [flu],
> it was a heart attack, it was something that made idleness a
> pleasure. With a stiff upper lip and a straight eye she set her-
> self to the solution of her problem, to the mastery of this
> unexpected fate. . . . Although she never regained the ability to
> walk, or to write except with difficulty, she did recover
> an extraordinary degree of strength, and made the most of every
> bit she could muster.

Isabella Stewart Gardner's stroke left her largely incapacitated for the last four years of her life. She saw very few people, and correspondence in the archives bursts with pleas from her friends to visit her, even in her physically diminished state.

Gardner made an exception for her longtime confidante John Singer Sargent. Nearing completion of his mural ceiling at the nearby Museum of Fine Arts, he repeatedly invited her for a sneak preview.

FIG. 71 John Singer Sargent, *Mrs. Gardner in White*, 1922

In June 1920, she finally accepted but was too weak and sensitive about her appearance to make a public entrance. Sargent arranged for her to avoid scrutiny by arriving via a back door, riding up in a freight elevator, and being carried by the museum's staff out onto the scaffold in a bath chair.

During one of these visits, Sargent created a touching and vulnerable image of Gardner (fig. 71), which is striking for its intimacy and for its differences from the imposing oil portrait he had painted in 1888,

FIG. 72 Arthur E. Marr, Isabella Stewart Gardner's Funeral, 21 July 1924

more than thirty years earlier (see fig. 36). The watercolor shows Isabella tiny, smooth faced, and wrapped mummy-like in white cloth, which had apparently become her clothing of choice after the stroke. The way she reclines, enveloped in material, is in direct contrast to her assertive stance and the closely tailored, revealing black dress that she wore in her formal portrait. If she looks like an imposing icon in the 1888 canvas, the watercolor presents her almost as a living relic. One friend, Elsie de Wolfe, likened it to "primitive pictures of saints." Despite her sensitivity to public appearances, Gardner was not ashamed of this image and displayed it prominently in the Macknight Room, where she spent much of her time in final years. Age and illness were not hidden away, but rather the capstone to an exceptionally full life.

Isabella died on July 17, 1924, in her living quarters on the fourth floor of the Museum. She left detailed instructions for her funeral (fig. 72), and her niece Olga Monks and Morris Carter carried out her wishes to the letter.

> Directions for my funeral. Please have an oak coffin not a black cloth casket. I want it long enough, that inside the head is not jammed in, as so often happens. Please use the purple pall which is now at the Church of the Advent. Have it put over the

coffin at Fenway Court as soon as the lid is on + do not have it ever taken off.

I should like to have the coffin carried up the aisle up high on the shoulders as it were. It would be very nice if 6 or 8 of the Brookline men were strong enough + could do it. But they would have to be told exactly how to do it.

If violets are in season, I should like to have one long cross of them on the coffin, going the whole length, + the arms of the cross the whole width with a small bunch of white heather and white roses attached. If not violet season, I should like to have white roses and white heather (both are Stewart and Scotch)—the cross still being of the entire length and width of the coffin. The enclosed piece of Tartan ribbon to be tied on the cross somewhere inconspicuously whether violets, or white roses and heather.

FIG. 73 Spanish Chapel

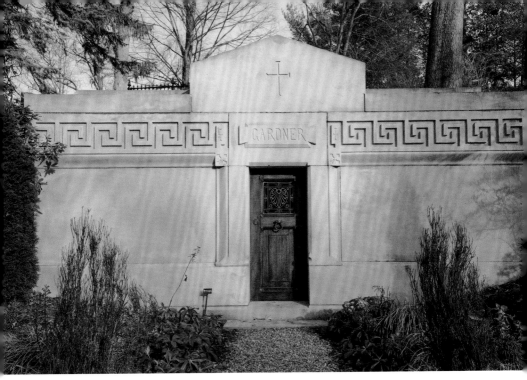

FIG. 74 Gardner Family Tomb at Mount Auburn Cemetery, Cambridge, Massachusetts

I should like the following for honorary pallbearers as many of them as can and will. Loeffler, Proctor, Potter, Swift, Johns, Ingersoll, one of the Cushings, ~~one of the Houghtons (Graeme preferably)~~, John S. Sargent, Andrew, Sleeper, Carter, Joe Smith, Martin Mower, and Chandler Post.

I should like to be in the Chapel Fenway Court [fig. 73], feet to the Altar, with four high candles lighted (one at each corner of the coffin) all the time until the funeral, at the Church of the Advent, and all of the time one of the Sisters of St. Margaret or St. Anne's to be in the Chapel; also any friend or friends who come to pray there. I do not want to be looked at, and please, dear Olga, remind Paul Thorndike of his promise to me. I should like to have all the Brookline men, all the servants (male and female) and Bolgy (of course I include the gardener and the night watchman who works at Fenway Court) fitted out with mourning clothes.

Forgive me for all these details. I think it may perhaps make it easier for you.

Isabella Stewart Gardner

P.S – My burial clothes I have arranged with Ella. Please have the coffin bought as soon as possible, that I may instantly be placed in it and be in the Chapel at Fenway Court until the funeral. I should like to have a small piece of white heather by my hands when lying there and have the entire top of the coffin off. When it is best to put the top on, please have the purple pall, put over it directly—

I.S.G.

Her funeral was a day to remember. William Crowinshield Endicott described it to John Singer Sargent:

At the Church of the Advent the service was the same, even to the hymns that she had had for her husband. She did not desire any flowers sent at all, but many friends did send flowers, which were placed on the floor in front of the Chapel, so that nobody could see them. . . . The music was beautiful! A choir of fifty men and boys. There were sixteen pallbearers, and her nephews and nieces followed her coffin. She was buried in the very commonplace Gardner Tomb at Mount Auburn [figs. 74, 75]. It really seemed out of keeping with her and her traditions, but she lies there between her husband and her boy.

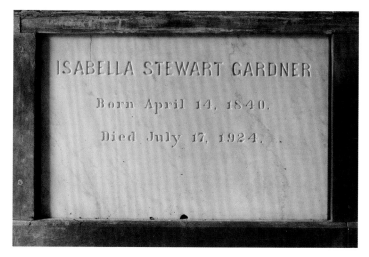

FIG. 75 Isabella Stewart Gardner's mausoleum plaque in the Gardner Family Tomb at Mount Auburn Cemetery

CODA

Today, the unusual architecture and atypical installations of Gardner's Museum may seem quaint or old-fashioned. In fact, they not only embody Gardner's pioneering and original curatorial vision, privileging an immersive aesthetic experience, but also showcase her highly modern museum practices—which became evident after her death. Jack had been a donor and trustee of Boston's Museum of Fine Arts, and he also served as the institution's treasurer. In addition to learning about the larger museum from her husband, Gardner was a friend of many of its other leaders, including its secretary, Matthew Prichard, and curator of paintings, John Briggs Potter. In this way, she had plenty of personal experience to draw on in planning for her own institution's long-term future. And she was far ahead of her time in seeing the need for efficient and effective museum management.

First and foremost, she recognized the need for sustainable funding. As soon as Isabella broke ground on the Museum, she began to plan for its financial future. She scaled back her lifestyle significantly: she stopped traveling extensively and limited her spending, apparently even including the amount of food she purchased. Isabella's choice to have apartments added to the top floor of the Museum may have seemed like an indulgence—a desire to live in her "whimsical" palace. However, it actually offered an opportunity to economize. Over the following years, she sold her other residences—152 Beacon Street and even her beloved

FIG. 77 Chapel

FIG. 76 Isabella Stewart Gardner's signature on her last will and testament

Green Hill property in Brookline—to both strangers and family members. The sales raised capital for investment in the Museum and its collection, while also lowering her costs of living. By the time she died, the Museum was her only residence. She had saved enough money to leave a generous endowment of $1.2 million (about $19 million today) providing income to sustain the Museum for years to come. She modeled the good fiscal stewardship she asked of her trustees. The will specifically urges them to be financially responsible and not to dip into the principal of the endowment.

Realizing that most museum boards, such as that of the Museum of Fine Arts, were constituted of local businessmen accustomed to steering an institution in their own manner, Gardner also designed a governing structure that restricted her trustees' power. The most famous of these limitations prohibits permanent alterations to her gallery installations. The penalty for the trustees "at any time changing the general disposition or arrangement of any articles which shall have been placed in the first, second, and third stories of said Museum at my death" is that everything should be sold, and the proceeds—including the amount of the endowment—should be given to Harvard College. This is not the only quirk of the will (fig. 76). A lesser known provision, but one written before the instruction about the installations, is that Isabella specifically directed the trustees to hold a yearly memorial service on the anniversary of her birthday, April 14, in the Chapel at the end of the Long Gallery (figs. 77, 78)—a tradition the Museum faithfully maintains. Isabella was just as intentional about the Museum's future after her death as she was about its design and installation while living.

FIG. 78 Chapel, showing a table with a cloth crocheted by Isabella

Despite these unusual stipulations, Gardner empowered and rewarded trained museum professionals in ways that were groundbreaking for the time. She gave the director of the Museum broad latitude, in addition to the right to live in her apartment on the fourth floor of the palace. She carefully chose the first, Morris Carter, former assistant director of the Museum of Fine Arts and worked closely with him for years. The privileges of his position would pass to his successors; Gardner trusted professionals with training in the arts more than the businessmen who were expected to make up a museum board. To ensure that her Museum would exist "for the education and enjoyment of the public forever," she appointed as the first trustees people who understood her intentions—designer Henry Davis Sleeper, professor of art history and artist Arthur Pope, her nephew and lawyer Harold J. Coolidge, and politician Grafton D. Cushing.

There is, beyond all this, one final coup in the will that secured Isabella's public recognition in perpetuity. She instructed that a piece of marble covering the inscription on the front of the Museum be removed, thus revealing its official name—the Isabella Stewart Gardner Museum (fig. 79). With this simple change, which retired the name Fenway Court, Isabella guaranteed that, as long as her Museum existed, she too would be in the spotlight: forever a notable and intriguing figure whom people would talk and wonder and write about, even a century or more after her death.

FIG. 79 Sarah Wyman Whitman, Plaque for Isabella Stewart Gardner Museum, 1900

NOTES

The holdings of the Isabella Stewart Gardner Museum and Archive are cited by inventory number only. Archive objects without a number are cited with the abbreviation "ISGM Archive."

PP. 12–15 Quotation source: "Mrs. Jack's Latest Lion: The Society Leader Chooses, Not a Man This Time, but a Real King of Beasts," *Boston Sunday Post*, 31 January 1897, p. 9.

P. 15 On Isabella's jiu-jitsu lessons, see "Ware Mrs. Gardner—Now Quite a Jiu-Jitsu Expert—Learned Trick of Uchimura," [unknown newspaper], 13 February 1906. The Symphony story appeared in the syndicated column "Town Topics"; see *Town Topics*, vol. 68, November 1912, p. 239.

On the destroying of Isabella's letters: Thomas Jefferson Coolidge (American, 1831–1920), Letter to Isabella Stewart Gardner from Boston, 26 April 1884 (ARC.000914): "I destroy your letters in obedience to your commands but I do it with regret, they ought to be collated with all the others and published."

For the correspondence with Berenson, see Rollin van N. Hadley, ed., *The Letters of Bernard Berenson and Isabella Stewart Gardner 1887–1924* (Boston, 1987).

P. 16 The previous biographies of Isabella are: Morris Carter, *Isabella Stewart Gardner and Fenway Court* (Boston, 1925; reprint, Boston, 1972); Louise Hall Tharp, *Mrs. Jack: A Biography of Isabella Stewart Gardner* (Boston, 1965; reprint, Boston, 2016); and Douglass Shand-Tucci, *The Art of Scandal: The Life and Times of Isabella Stewart Gardner* (New York, 1997).

P. 19 Items in the Mary Queen of Scots Case include: Belgian, *Lace Fragment*, 16th century, needle and bobbin lace, 13.3 × 10.2 cm (5¼ × 4 in.) (T27e41); The Stewart Society (established 1899, Edinburgh, Scotland),

Lifetime Membership Certificate for Isabella Stewart Gardner, 19 April 1921 (ARC.008908); Alfred John Rodwaye (active Boston, 1893–1914), Invitation from the Order of the White Rose, 30 January 1900 (ARC.009393); and Scottish, *Two Tassels*, about 1561–1568, silk and velvet, 2 cm (¹³⁄₁₆ in.) wide (T27e822.1-2).

Quotation source: Carter, *Isabella Stewart Gardner*, p. 4.

On Isabella's siblings, see ibid., p. 10.

P. 20 For Adelia Smith Stewart's parentage, see Adelia Stewart Death Record, 6 January 1886, New York Municipal Archives, New York, FHL microfilm 1,373,979.

For Selah Smith's will, see Estate of Selah Smith to Ann Smith, 2 November 1918, New York Wills and Probate Records, Letters of Administration, Vol 1–2 (Kings County, New York), 1787–1923, p. 122.

On the Smiths as enslavers, see Tharp, *Mrs. Jack*, p. 5. See also Frederick Kinsman Smith, *The Family of Richard Smith of Smithtown, Long Island* (Smithtown, NY: Smithtown Historical Society, 1967), pp. 321–22. While the census did not note the race of enslaved people, the enslaved persons in the Smith household were likely Black.

P. 21 The ending of slavery in New York State was a gradual process. According to the New-York Historical Society, "In 1799, New York passed a Gradual Emancipation act that freed slave children born after July 4, 1799, but indentured them until they were young adults. In 1817 a new law passed that would free slaves born before 1799 but not until 1827. By the 1830 census there were only 75 slaves in New York and the 1840 census listed no slaves in New York City." New-York Historical Society, "When Did Slavery End in New York State?" https://www.nyhistory.org/community/slavery-end-new-york-state.

P. 23 Quotation source: Carter, *Isabella Stewart Gardner*, p. 11.

Items that belonged to Isabella Tod Stewart: Isabella Tod Stewart (American, 1778–1848), *Music Book*, 1792 (ARC.009117); David Tod (Scottish-American, 1746–1827), Letter to Isabella Tod Stewart from Bedford, New York, 5 September 1823 (ARC.008856).

For her lineage, see Genealogy of Isabella Tod and the Kent Family, 19th century (ARC.009025).

On David Tod, see Edward Chase, "Suffield Proprietor Thomas Copley," *Stony Brook Current: The Newsletter of the Suffield Historical Society* 8, no. 2 (April 2018): p. 2n2.

David Tod's household contained four enslaved people in 1790. Guocun Yang, "From Slavery to Emancipation: The African Americans of Connecticut: 1650s–1820s," PhD diss, University of Connecticut, 1999, p. 286. Slavery in Connecticut can be traced back to the mid-1600s. The state took a gradual approach to abolition, passing a law in 1784 that any child born into bondage after that date would be freed by age twenty-five. Slavery existed in Connecticut until 1848. See "Connecticut Abolitionists," National Park Service, https://www.nps.gov/articles/connecticut-abolitionists.htm.

Quotation source: John Tod, "Isabella Tod 1778–1848," in "History of the Tod Family," 1917 (ARC.008798).

P. 24 Marriage notice of Isabella Tod and James Stewart: "Married," *New York Evening Post*, 16 December 1805, p. 3.

For the "free colored persons" who resided with Isabella Tod Stewart, see Entry for Isabella Stewart, Jamaica, Queens, New York, United States, US Census 1840, The U.S. National Archives and Records Administration, p. 98.

Quotation source: Carter, *Isabella Stewart Gardner*, p. 10.

For David Stewart's enterprises, see "Obituary of David Stewart," *New York Times*, 19 July 1891, p. 2.

PP. 24–25 Regarding Stewart's trade in "linens": Though linen is traditionally made of flax, the term "linens" was often applied to any material with a linen weave, including textiles made of cotton. In some respects, Scotland and Ireland were far more dependent on slave economies than England during this period, as they were poorer and had fewer resources at their disposal with which to fund industrialization. Although the relative interconnectedness of the trade in Scottish and Irish linens and the slave economies of the Atlantic World shifted throughout this period, after the American Revolution, the Caribbean slave markets for Scottish linen became especially important. For more on the American trade with Scotland, See, T. M. Devine. "Did Slavery Make Scotia Great? A Question Revisited," in *Recovering Scotland's Slavery Past: The Caribbean Connection*, edited by T. M. Devine (Edinburgh, 2015), p. 236.

Imported linens received by David Stewart in New York City seem likely to have been intended for use in slave regimes. Based on our research, it is probable that he exited the textile importation business during or immediately after the Civil War, which suggests that his enterprise was directly linked to the U.S. South and/or Caribbean slave economies. Only by tracking the flow of this trade in archival materials can this be clarified. See Iain Hutchison, *Industry, Reform, and Empire: Scotland, 1790–1880* (Edinburgh, 2020), p. 38.

P. 25 On David and George Tod, see John Tod, *Some Account of the History of the Tod Family and Connections* (Youngstown, OH, 1917), p. 32.

For a discussion of the creation of extreme wealth in this period and its social consequences, see Sven Beckert, *The Monied Metropolis: New York City and the Consolidation of the American Bourgeoisie, 1850–1896* (Cambridge, UK, 2001).

On David Stewart's status in New York society, see "Obituary of David Stewart."

Marriage notice of David Stewart and Mary Elizabeth Hicks Peck: "Married,"

New-York Tribune, 29 April 1887, p. 5. Mary Elizabeth's relation to Isabella is clear: Mary Ann Smith Hicks was, like Adelia Smith Stewart, a daughter of Selah Strong Smith and Anna Carpenter; see Mary Ann Hicks Death Record, 21 December 1877; New York Municipal Archives, New York, FHL microfilm 1,323,736. Mary Elizabeth Hicks Peck was her daughter; see "New York State Census, 1875," p. 27, line 20, State Library, Albany, FHL microfilm 1,930,213.

P. 27 Marriage Record for Albert Bierstadt and Mary Hicks Stewart, New York City Municipal Archives, New York, FHL microfilm 1,439,744. See also "Many Bierstadt Bequests: Artist's Widow's Will Disposes of $1,200,000 Estate," *New York Times*, 10 October 1916, p. 11.

On Isabella's inheritance, see Carter, *Isabella Stewart Gardner*, p. 121. For dollar values, see Samuel H. Williamson, "Seven Ways to Compute the Relative Value of a U.S. Dollar Amount, 1790 to Present," Measuring-Worth, https://www.measuringworth.com/calculators/uscompare.

The account ledgers showing David Stewart's investments: Ledger for Account Current Income, 1891–1900 (ISGM Archives).

For an overview of global trade in the eighteenth century, in connection with the Peabodys, see Ronald Findlay and Kevin H. O'Rourke, *Power and Plenty: Trade, War, and the World Economy in the Second Millennium* (Princeton, NJ, 2007), pp. 227–425.

For Joseph Peabody's involvement in the opium trade, see Jacques M. Downs, "Merchants and the China Opium Trade, 1800–1840," *The Business History Review*, Winter, 1968, Vol. 42, No. 4 (Winter, 1968), p. 430; Charles C. Stelle, "Trade in Opium to China, 1821–39," *Pacific Historical Review*, Mar., 1941, Vol. 10, No. 1 (Mar., 1941), p. 65. Thank you to Stephanie Tung from the Peabody Essex Museum for providing these sources.

On alliances among elite Boston families, see Robert Dalzell, *Enterprising Elites: The Boston Associates and the World They*

Made (Cambridge, MA, 1987), pp. 79–81. For more on the involvement of the United States in Sumatra, see Gregory W. Swedberg, "'Deeply Wronged': American Diplomacy and the Origins of the Last Dutch War for Empire in Sumatra," *Journal of Asian History* 44, no. 1 (2010): pp. 38–50.

P. 28 Quotation source: Josiah Blakely (Santiago, Cuba), letter to Samuel Gardner (Boston), 11 November 1799, Samuel Pickering Gardner correspondence, 1800, Mss. 899, Box 1, Folder 9, Baker Library Special Collections, Harvard Business School, Cambridge, MA.

For Mary Gardner Lowell's eyewitness account of slave labor in Cuba, see her *New Year in Cuba: Mary Gardner Lowell's Travel Diary, 1831–1832* (Boston, 2003).

On the Gardner family's investing strategy, see Daniel Vickers and Vince Walsh, "The Nineteenth Century," in *Young Men and the Sea: Yankee Seafarers in the Age of Sail* (New Haven, 2005), pp. 163–213.

For records of Isabella's school years, see Isabella Stewart Gardner (American, 1840–1924), *Autograph Album*, 1854–1861 (ARC.009129).

P. 29 On Isabella's fluent French, see "Met a Real Lion," *Boston Globe*, 2 December 1896, p. 8. On her Italian, see Carter, *Isabella Stewart Gardner*, pp. 14–15. On her Spanish, see "Met a Real Lion," *Boston Globe*, 2 December 1896, p. 8.

Quotation source: John L. Gardner Jr., letter to George Gardner from Naples, Italy, 2 May 1858, Gardner Family Papers, Massachusetts Historical Society, Boston.

P. 30 For the death of Helen Waterston, see Carter, *Isabella Stewart Gardner*, p. 15.

P. 31 Julia Gardner's letter to her father is quoted in ibid., p. 16. This letter survives only in transcription.

For Joseph Gardner's inscription, see Gardner, *Autograph Album*, p. 169.

Regarding Jack Gardner's college career: "He entered with the class of 1858, but left

at the end of Sophomore year in good standing. Harvard gave him an honorary degree in 1898 as of the class of 1858"; Frank A. Gardner, *Gardner Memorial: Thomas Gardner, Planter, Cape Ann, 1624; Salem (Naumkeag), 1626–1674 through his son Lieut. George Gardner* (Salem, MA: Newcomb and Gauss, 1933), p. 200. See also Harvard College (1780–), Class of 1858, "Report of the Class of 1858, Harvard College: Prepared for the Fortieth Anniversary of its Graduation" (Boston, 1898), pp. 43–44, Harvard University Archives, Harvard University, Cambridge, MA, HUD 258.40.

Joseph Gardner married Harriet Sears Amory, and George Gardner married Eliza Endicott Peabody; both women were from Boston Brahmin families.

Quotation source: Carter, *Isabella Stewart Gardner*, p. 18, from a transcript of a letter from Isabella Stewart Gardner to Julia (née Gardner) Coolidge lent to Carter by the Coolidge family. The location of the original letter is unknown.

Quotation source: John L. Gardner, letter to George Gardner from New York, 25 February 1859, Gardner Family Papers, Massachusetts Historical Society, Boston.

P. 32 A wedding announcement for Isabella and Jack appeared in the *Boston Evening Transcript*, 14 April 1860, p. 2.

Julia Gardner's letter is quoted in Carter, *Isabella Stewart Gardner*, p. 20.

For the gift of the Beacon Street property, see ibid., p. 23. See also John Lowell Gardner Jr. (American, 1837–1898), Notes on furnishing 152 Beacon St., Boston, 1860–1861 (ARC.009917).

On Isabella's social difficulties, see Tharp, *Mrs. Jack*, p. 29.

P. 33 The children of Julia Gardner Coolidge and Harriet Sears Amory Gardner were: Joseph Randolph Coolidge, born 1862, and John Gardner Coolidge, born 1863; Joseph Peabody Gardner, born 1861, and William Amory Gardner, born 1863. See Tharp, *Mrs. Jack*, p. 30, family tree.

On Massachusetts during the Civil War and the politics of the era, see Thomas H. O'Connor, *Civil War Boston: Home Front and Battlefield* (Boston, 1997), pp. 3–61; and Reinhard H. Luthin, "Abraham Lincoln and the Massachusetts Whigs in 1848," *New England Quarterly* 14, no. 4 (December 1941): pp. 619–32.

Quotation source: Maud Howe Elliott, *Three Generations* (Boston, 1923), pp. 57–58.

P. 35 On Jack's apolitical nature, see "John L. Gardner Dead: Expired Suddenly of Apoplexy Saturday Evening," *Boston Daily Globe*, 12 December 1898, p. 12.

For Jack and his father's membership in the Somerset Club: Somerset Club, *Constitution and By-Laws of the Somerset Club with a List of Its Officers and Members* (Boston: Alfred Mudge, 1853), p. 21; Somerset Club, *Constitution and By-Laws of the Somerset Club with a List of Its Officers and Members* (Boston: John Wilson and Son, 1873), p. 34.

Jack's friend records paying a substitute draftee: Thomas Jefferson Coolidge, *T. Jefferson Coolidge, 1831–1920: An Autobiography* (Boston: Massachusetts Historical Society, 1923), p. 42; note that Tharp uses this fact to extrapolate that Jack also paid a substitute—but this is not supported by any evidence. For dollar amount conversion, see "How much is a dollar from the past worth today?" MeasuringWorth, www.measuringworth.com/dollarvaluetoday. For information about the Enrollment Act, also known as the Conscription Act, see Iver Bernstein, *The New York City Draft Riots: Their Significance for American Society and Politics in the Age of the Civil War* (New York, 1990), pp. 8–10.

P. 36 Quotation source: Carter, *Isabella Stewart Gardner*, p. 25.

For Jackie's death, see interment record for John Lowell Gardner 3rd, 27 November 1868, Gardner Family Tomb, Lot 2900 Oxalis Path, courtesy of Historical Collections & Archives, Mount Auburn Cemetery, Cambridge, MA. See also Tharp, *Mrs. Jack*, p. 36.

Quotation source: Carter, *Isabella Stewart Gardner*, p. 27.

PP. 36–38 Quotation source: Elizabeth Cabot Lowell, letter to Augustus Lowell, 10 December 1865, Lowell Family Papers, 1836–1928 (MS Am 3166), Houghton Library, Harvard University, Cambridge, MA.

P. 39 See "confinement, n.," in OED Online, September 2021, Oxford University Press, https://www-oed-com.ezproxy.cul .columbia.edu/view/Entry/38840 (accessed 28 October 2021).

On Isabella's depression, see Tharp, *Mrs. Jack*, pp. 36–37. For the recommendation that she travel: Carter, *Isabella Stewart Gardner*, p. 28.

P. 44 Tharp, *Mrs. Jack*, pp. 41–47, discusses Isabella's defiance of expectations.

For more on Gardner's travel albums, see Casey Riley, "From Page to Stage: Isabella Stewart Gardner's Photograph Albums and the Development of Her Museum, 1874–1924," PhD Diss., Boston University, 2015.

P. 45 See Lawrence M. Berman, "Aboard the *Ibis*: The Gardners' Nile Voyage, 1874–1875," in *Inventing Asia: American Perspectives around 1900*, ed. Noriko Murai and Alan Chong (Boston, Isabella Stewart Gardner Museum, 2014), pp. 64–65. For the influence on Isabella of the Bible and *The Arabian Nights*, see ibid., pp. 66–67.

Quotation source: Isabella Stewart Gardner, Travel Album: Egypt, 1874–1875 (v.1.a.4.2), p. 69.

P. 49 On Isabella's desire to pursue further education: Tharp, *Mrs. Jack*, pp. 57–61.

P. 50 For Isabella's attendance at Dante readings by Charles Eliot Norton, see Carter, *Isabella Stewart Gardner*, p. 54.

Isabella Stewart Gardner, Notebook with History and Art History Notes, 1883 (ARC.009116).

Joseph Peabody Gardner Jr. was a graduating member of the class of 1882. See Harvard College (1780–), Class of 1882,

Baccalaureate Sermon, Class Day Oration, Etc. (Cambridge: Wm. H. Wheeler, printer, 1882); https://hdl.handle.net/2027/uc2.ark: /13960/t4or9pd6f.

P. 53 On Isabella's friendship with Francis Marion Crawford, see Rachel Jacoff, "Dante," in *Eye of the Beholder: Masterpieces from the Isabella Stewart Gardner Museum*, ed. Alan Chong, Richard Lingner, and Carl Zahn (Boston, 2003), pp. 72–73.

P. 54 See Alan Chong and Noriko Murai, *Journeys East: Isabella Stewart Gardner and Asia*, exh. cat. (Boston: Isabella Stewart Gardner Museum, 2009), pp. 98–99; Tharp, *Mrs. Jack*, p. 105.

Because the Museum does not hold a purchase receipt for the *Tale of Genji* screens, their acquisition on this trip is possible but not entirely likely. Isabella and Jack did purchase two other screens on this trip: *Spring* (P29w7.a) and *Autumn* (P29w7.b).

PP. 56–57 Quotation source: Isabella Stewart Gardner, Travel Diary: Asia, Egypt, and Italy, 1883–1884 (ARC.009111), p. 11.

P. 59 For Gardner's devotion to the Church of the Advent, see Betty Hughes Morris, *A History of the Church of the Advent* (Boston, 1996), p. 46.

Quotation source: "Fascinating 'Mrs. Jack': The Most Brilliant and Conspicuous Figure in Social Boston," *Boston Courier*, 1891 (ARC.009943).

Quotation source: Gardner, Travel Diary: Asia, Egypt, and Italy, 1883–1884, p. 159.

P. 60 On the economy of Venice, see Elizabeth Anne McCauley, "A Sentimental Traveler: Isabella Stewart Gardner in Venice," in Elizabeth Anne McCauley et al., *Gondola Days: Isabella Stewart Gardner and the Palazzo Barbaro Circle* (Boston, 2004), p. 24.

PP. 63–64 See Shana McKenna, "Green Hill and Its Gardens," *Inside the Collection* (blog), Isabella Stewart Gardner Museum, 28 July 2020, https://www.gardnermuseum. org/blog/green-hill-gardens.

P. 64 On the homes at Prides Crossing, see "Mrs. John L. Gardner: The Home, Life, and Treasures of Boston's Famous Social Leader," *Boston Journal*, 14 April 1893. This source also describes the Gardners' seasonal movements.

Roque Island was sold out of the family in 1868, and Jack and his brother George bought it back in 1882.

P. 65 The London sale offered manuscripts and rare books collected by Edward Cheney.

P. 66 Walter Pater (London, 1839–1994, Oxford), Letter to Isabella Stewart Gardner from London, 12 October 1886 (ARC.004474).

On the Boston Public Library's "Books in Inferno," see McCauley, "A Sentimental Traveler," pp. 49–50n138.

P. 69 Jack's request is recorded in Morris Carter, Note, 30 October 1939 (ISGM Archives).

Quotation source: Isabella Stewart Gardner, letter to Bernard Berenson from Brookline, MA, 26 August 1907, in Hadley, *The Letters*, p. 405.

PP. 71–73 Quotation source: Van Wyck Brooks, *New England: Indian Summer, 1865–1915* (New York, 1940), pp. 435–37.

P. 78 Quotation source: Ralph Wormeley Curtis (United States, 1854–1922), Letter to Isabella Stewart Gardner from Villa Silvia, Saint-Jean-Cap-Ferrat, 25 December [1904–1910] (ARC.001191).

Quotation source: Bernard Berenson (American, 1865–1959), Letter to Isabella Stewart Gardner from Florence with Enclosed Biographical Note, 15 April 1900 (ARC.008478).

PP. 78–79 Quotation source: Isabella Stewart Gardner, letter to Bernard Berenson from Brookline, MA, 26 August 1907, in Hadley, *The Letters*, p. 154.

P. 79 Quotation source: Bernard Berenson, Letter to Isabella Stewart Gardner from Florence, 12 June 1898 (ARC.006475).

P. 80 "Boston May Lose a Picture: Mrs. Gardner's Botticelli Has Caused Trouble in Italy," [unknown newspaper], 2 September 1902 (ISGM Archives).

Quotation source: Anders Zorn, *Självbiografiska anteckningar* (Mora, Sweden, 2004), p. 127.

P. 83 Letters addressed to "Queen Isabella" include: Ralph Wormeley Curtis (American, 1854–1922), Letter to Isabella Stewart Gardner from the Atlantic Ocean, 13 April 1894 (ARC.001160); Elsie de Wolfe (American, 1859–1950), Letter to Isabella Stewart Gardner from Boston, 27 January 1920 (ARC.001314).

Quotation source: Henry James (American, 1843–1916), Letter to Isabella Stewart Gardner from Paris, 1 May 1893 (ARC.002223).

Quotation source: Thérèse Bentzon, *The Condition of Woman in the United States: A Traveler's Notes* (Boston, 1895), p. 131.

P. 84 For Isabella's patronage of musicians, see Ellen E. Knight, *Charles Martin Loeffler: A Life Apart in American Music* (Urbana, IL, 1993), pp. 12, 203; Ralph P. Locke and Cyrilla Barr, *Cultivating Music in America: Women Patrons and Activists since 1860* (Berkeley, CA, 1997), p. 108.

PP. 84–85 Quotation source: Thomas Russell Sullivan, *Extracts from the Journal of Thomas Russell Sullivan, 1891–1903* (Boston, 1917) pp. 160–61.

P. 87 Quotation source: Willard Thomas Sears (American, 1837–1920), Diary Pages on the Building of Fenway Court, 1896–1911 (ARC.007373), entry for 1 September 1896.

P. 88 For Isabella's first art exhibition, see Isabella Stewart Gardner, Art Exhibition at 152 Beacon Street, 1900 (ARC.008726). Her beneficiary, the Industrial School for Crippled and Deformed Children, now known as the Cotting School, was founded in Boston in 1893 and was the first school in the United States established for children with disabilities.

For Isabella's comment on the Poldi Pezzoli collection, see Ida Higginson

(American, 1837–1935), Letter to Isabella Stewart Gardner from Rome, 8 March 1923 (ARC.001812).

Isabella signed the Hertford House Visitors Book on 18 June 1890 with De Wolfe (p. 148) and on 23 July 1897 with Berenson (p. 240). See Sir Richard Wallace, Hertford House Visitors Book, 1876–1897, The Wallace Collection Archive, HHVB, https://archive.org/details/HHVB1876_1897/mode/2up.

PP. 88–89 Corinna Lindon Smith, *Interesting People; Eighty Years with the Great and Near-Great* (Norman, OK, 1962), p. 154.

P. 89 Quotation source: Isabella Stewart Gardner, letter to Bernard Berenson from Boston, 1 January 1897, in Hadley, *The Letters*, p. 72.

Quotation source: Henry L. Higginson, Letter to Isabella Stewart Gardner from Boston, 12 December 1898 (ARC.001781).

PP. 89–90 Quotation source: Sears, Diary Pages on the Building of Fenway Court, 1896–1911, entry for 30 December 1898.

P. 90 Quotation source: Isabella Stewart Gardner, Letter to Willard T. Sears from Venice, 16 August 1899 (ARC.007081).

P. 94 Bernard Berenson, Mary Smith Costelloe, and Logan Pearsall Smith, "Altamura," *The Golden Urn*, no. 3 (July 1898), pp. 99–107; Gardner's copy is in the Museum's holdings (v.1.a.1.12).

On Isabella's use of Berenson's Altamura idea, see Robert Colby, "Palaces Eternal and Serene: The Vision of Altamura and Isabella Stewart Gardner's Fenway Court," in *Bernard Berenson: Formation and Heritage*, ed. Joseph Connors and Louis A. Waldman (Florence, 2014), pp. 69–100; and Alan Chong, "Mrs. Gardner's Museum of Myth," *Res: Anthropology and Aesthetics* 52 (Autumn 2007), pp. 212–20.

p. 95 Quotation source: Sears, Diary Pages on the Building of Fenway Court, 1896–1911, entry for 1 September 1896.

Popular-press coverage of the Museum while under construction: "Mrs. 'Jack' Gardner's Palace Mystifies Back Bay Bostonians," *Philadelphia Press*, 17 March 1901 (ARC.100017); "Weird Wall Shuts Mrs. 'Jack' Gardner's Palace in from the World and Causes Speculation among the Curious Who Watch It Growing," *Boston Herald*, 19 June 1901 (ISGM Archives); "The Latest Whim of America's Most Fascinating Widow," *New York Journal and Advertiser*, 17 December 1899, p. 11.

Quotation source: Sears, Diary Pages on the Building of Fenway Court, 1896–1911, entry for 25 March 1901.

P. 96 Ibid., entry for 14 February 1902, reports Isabella calling her foreman a "thief."

Contractors' names are recorded in Isabella Stewart Gardner, Financial Ledger, vol. 1, 1900–1902, and Financial Ledger, vol. 2, 1903–1909 (ISGM Archives).

P. 97 For Isabella's meeting with carpenters, see "About 750 Out: Carpenters' Strike for 8 Hours Begun. Estimated That 600 Men Were Granted Demands. Work on Mrs Gardner's House Delayed. She Is Reported to Have Appeared Annoyed. Lathers Adopt New Scale to Go in Force on Saturday," *Boston Daily Globe*, 2 July 1901, p. 12; and "No Social Call. Building Laborers Will Visit Mrs. Gardner. Will State Grievances at Her Thursday 'At Home.' Men Receive $1.50 a Day When $2 Is Their Due," *Boston Daily Globe*, 13 May 1901, p. 1.

P. 99 Commonwealth of Massachusetts, Certificate of Incorporation for the Isabella Stewart Gardner Museum in the Fenway, 19 December 1900 (ARC.007324).

"Inside Mrs. J. L. Gardner's Splendid Treasure House," *Boston Daily Globe*, 5 January 1902, p. 40.

Quotation source: Isabella Stewart Gardner, letter to Bernard Berenson from Boston, 4 March 1900, in Hadley, *The Letters*, p. 207.

P. 103 For the Museum's Music Room, see Carter, *Isabella Stewart Gardner*, p. 199.

P. 105 For the Museum's location, see "Boston City Growing on the Dump," *Boston Sunday Post*, 5 August 1906, p. 22.

P. 106 Quotation source: Henry James, Letter to Isabella Stewart Gardner, 3 April 1898 (ARC.002232).

Quotation source: Charles Eliot Norton (American, 1827–1908), Extract of Letter to Samuel Gray Ward, 2 March 1902 (ARC.1954.2.1).

On Wharton's reaction to Museum's opening night, see Tharp, *Mrs. Jack*, p. 245. This story seems to originate with Tharp, who is quoted as its source in the most recent authoritative biography of Wharton, Hermione Lee, *Edith Wharton* (London, 2007), p. 404.

P. 109 "Harvard Day at the Fenway Palace Today," *Boston Post*, 6 April 1903, p. 6. See also the thank you letter from the dean of Radcliffe: Agnes Irwin, Letter to Isabella Stewart Gardner from Cambridge, 22 December 1903 (ARC.002140).

For Wellesley and Mount Holyoke days, see the letters from students: Augie S. Ruhl, Letter to Isabella Stewart Gardner from Wellesley College, Wellesley, MA, 3 May 1903 (ARC.005482); Gertrude A. Merrich, Letter to Isabella Stewart Gardner from South Hadley, MA, 27 November 1909 (ARC.002340).

For Isabella taking tickets, see Morris Carter, Isabella Stewart Gardner, Tagebuch, 1920–1924, 3–8 April 1920 (ARC.009107).

On the "guardian ushers," see Tharp, *Mrs. Jack*, pp. 261–64.

P. 110 Quotation source: ibid., p. 345n7.

P. 111 Quotation source: Oral History Interview with Allan Rohan Crite, 16 January 1979–22 October 1980, Archives of American Art, Smithsonian Institution.

P. 113 Isabella Stewart Gardner, letter to Bernard Berenson from Green Hill, 22 August 1910, in Hadley, *The Letters*, pp. 477-78.

P. 114 Quotation source: Isabella Stewart Gardner, letter to Bernard Berenson, 3 May 1905, in Hadley, *The Letters*, p. 364.

On his meeting Isabella, see A. Piatt Andrew, Diary, 1903, A. Piatt Andrew papers, Box 1, Folder 18, Hoover Institution Library & Archives, Stanford, CA.

DABSville stands for: Joanna Davidge, A. Piatt Andrew, Cecilia Beaux, Caroline Sinkler, and Henry Davis Sleeper. For the refuge it provided, see Kevin D. Murphy, "Secure from All Intrusion," *Winterthur Portfolio* 43, no. 2/3 (Summer/Autumn 2009): pp. 189–94.

P. 115 On Dabsville social life, see Aurora Daniel, "Henry Davis Sleeper and a Glass Mosaic," *Inside the Collection* (blog), Isabella Stewart Gardner Museum, 8 June 2021, https://www.gardnermuseum.org/blog/henry-davis-sleeper-and-glass-mosaic.

A. Piatt Andrew, "The Crux of the Immigration Question," *North American Review* 199 (June 1914), pp. 866–78.

On the family rift, see Andrew Gray, "A New England Bloomsbury," *Fenway Court* (1974), p. 4.

P. 117 On Meyer Bloomfield, see "Boom Meyer Bloomfield as Next Secretary of Labor," *Jewish Daily Bulletin*, 27 July 1930, p. 2; https://www.jta.org/archive/boom-meyer-bloomfield-as-next-secretary-of-labor.

"Mrs. John L. Gardner: Hostess in a Novel Role," *Boston Globe*, 21 August 1905 (ARC.100018). See also Dakota Jackson, "Urban Gardening and Isabella's Flower Day Prizes," *Inside the Collection* (blog), Isabella Stewart Gardner Museum, 6 July 2021, https://www.gardnermuseum.org/blog/urban-gardening-and-isabellas-flower-day-prizes.

Gardner's name does not appear in voters' registries between 1920 and 1924. See Elizabeth Reluga, "Julia Ward Howe: BFF and Suffragette," *Inside the Collection* (blog), Isabella Stewart Gardner Museum,

2 November 2020, https://www
.gardnermuseum.org/blog/julia-ward-howe
-bff-and-suffragette.

See Christina Nielsen, ed., *Sargent on
Location: Gardner's First Artist-in-Residence*
(Boston and London, 2018).

P. 118 On philanthropic activities, see
Christina Nielsen, ed., *Isabella Stewart
Gardner Museum: A Guide* (Boston,
2017), p. 118.

Marjorie Sherman "Party Honors Roland
Hayes," *Boston Globe*, 5 June 1967, p. 19.

P. 119 Between 1901 and 1910, the all-Black
musical theater production *The Red Moon*
ran on Broadway and toured the United
States. The show was inspired by the
African American and Native American
educational program at Hampton Institute
in Virginia. See Paula Marie Seniors, "Cole
and Johnson's *The Red Moon*, 1908–1910:
Reimagining African American and Native
American Female Education at Hampton
Institute," *Journal of African American
History* 93, no. 1 (Winter 2008): pp. 21–35.

Quotation source: Isabella Stewart Gardner,
letter to Percy Grainger from Boston,
7 December 1915, Percy Grainger Museum,
University of Melbourne, Australia.

Ana Barrett, "The Sole American Music:
Spirituals During Isabella's Time," *Inside the
Collection* (blog), Isabella Stewart Gardner
Museum, 18 February 2021, https://www
.gardnermuseum.org/blog/sole-american
-music-spirituals-during-isabellas-time.

P. 123 Quotation source: Isabella Stewart
Gardner (American, 1840–1924), Letter to
Maud Howe Elliott from Osaka, Japan, 24
August 1883. Transcript in ISGM Archives.

During Isabella's lifetime, the Chinese Room
was rarely accessible to the public. In 1971,
administrators of the Gardner Museum
interpreted the room as not belonging to
the historic collection and auctioned off
the contents.

On Isabella's affinity for Spanish culture,
see Diana Seave Greenwald, "Spanish Music,
South Korean Choreographers, and the
Museum Archives," *Inside the Collection*
(blog), Isabella Stewart Gardner Museum,
15 April 2020, https://www.gardnermuseum
.org/blog/spanish-music-south-korean
-choreographers-and-museum-archives.

P. 126 Mary Crawford Volk et al., *John Singer
Sargent's* El Jaleo (Washington, D.C, 1992),
pp. 78–79.

Quotation source: Henry Davis Sleeper,
letter to A. Piatt Andrew from Gloucester,
8 April 1915, in *Beauport Chronicle: The
Intimate Letters of Henry Davis Sleeper
to Abram Piatt Andrew, Jr., 1906–1915*, ed.
E. Parker Hayden and Andrew L. Gray
(Boston, 1991), p. 85.

"Many New Artistic Treasures Have Been
Added to Mrs. John L. Gardner's Famous
Collection . . . ," *Boston Sunday Post*, 23 April
1916, Pictorial Section.

P. 129 Aurora Daniel, "Isabella and the
American Field Service During World War I,"
Inside the Collection (blog), Isabella
Stewart Gardner Museum, 9 November
2021, https://www.gardnermuseum.org
/blog/isabella-and-american-field-service
-during-world-war-i.

Ambrogio Lorenzetti (Italian, 1285–about
1348), *Saint Elizabeth of Hungary*, about
1319–1347 (P15n10).

P. 130 Quotation source: Anna Coleman
Ladd, (American, 1878–1939), Letter to
Isabella Stewart Gardner from Beverly
Farms, MA, 8 July 1920 (ARC.002398).

Quotation source: Carter, *Isabella Stewart
Gardner*, pp. 245–47.

PP. 132–35 Quotation source: Isabella
Stewart Gardner, Letter to Olga Monks,
1 August 1912 (amended at a later date)
(ARC.008640).

P. 132 The purple pall mentioned in Isabella's
funeral instructions is the same one that
was used at the funeral of her husband,
John. L. Gardner Jr. (ARC.007349).

P. 134 Isabella names the "Chapel Fenway Court"; she was laid out in what is now the Spanish Chapel, a space she had built in memory of her son.

P. 135 Quotation source: William Crowninsheild Endicott Jr. (American, 1860–1936), to John S. Sargent from Bar Harbor, ME, 24 July 1924 (ARC.007349).

P. 137 On Isabella's economies, see Tharp, *Mrs. Jack*, pp. 283–84, citing S. N. Behrman, *Duveen* (New York, 1951), n.p.

P. 138 The houses at 150–152 Beacon St. were sold to Eben Draper, 1904 (raized, 1904); Green Hill was sold to George Peabody Gardner (eldest son of Jack's brother George Augustus Gardner), 1 April 1919; land from Green Hill was given to nephew Harold Coolidge (son of Jack's sister Julia Coolidge), 1919; a house at 258 Warren St., to which Gardner had added architectural salvage from 152 Beacon St., was given to niece Olga Monks (daughter of Jack's brother George Augustus Gardner). This last property was formally transferred in Isabella's will, but Olga occupied it before then.

On the fiscal responsibility of her Museum's trustees, see Last will and testament of Isabella Stewart Gardner, 17 January 1924, probated 23 July 1924, Boston, Article 7, p. 8.

P. 141 Quotation source: ibid., Article 3, p. 3.

For the instruction to reveal the Museum's official name, see Isabella Stewart Gardner, Suggestions for Running the Isabella Stewart Gardner Museum in the Fenway, 16 July 1913 (ARC.008635). See also Carter, *Isabella Stewart Gardner*, p. 188.

APPENDIX 1
Countries Visited by Isabella

YEAR	COUNTRY (MODERN NAME)	YEAR	COUNTRY (MODERN NAME)
1867	Austria	1886	Germany
1867	Denmark	1886	Italy
1867	France	1888	Belgium
1867	Germany	1888	England
1867	Norway	1888	France
1867	Poland	1888	Germany
1867	Russia	1888	Italy
1867	Sweden	1888	Monaco
1874–75	Egypt	1888	Portugal
1874–75	Sudan	1888	Spain
1875	Greece	1890	Belgium
1875	Israel	1890	England
1875	Lebanon	1890	France
1875	Palestine	1890	Germany
1875	Syria	1890	Italy
1875	Turkey	1890	Netherlands
1879	England	1892	France
1879	France	1892	Germany
1883	Cambodia	1892	Italy
1883	China	1892	Switzerland
1883	Indonesia	1894	Austria
1883	Japan	1894	England
1883	Republic of Singapore	1894	France
1883	Vietnam	1894	Germany
1884	India	1894	Italy
1884	Malaysia	1895	Italy
1884	Myanmar	1897	Germany
1884	Pakistan	1897	Italy
1886	Austria	1906	England
1886	Cuba	1906	France
1886	England	1906	Italy
1886	France	1906	Spain

Teakwood cabinet in the Short Gallery

WHISTLER

APPENDIX 2
Isabella's Art Expenditures by Year

YEAR	AMOUNT RECORDED	AMOUNT IN TODAY'S DOLLARS
before 1892	$24,288	$753,332
1892	$25,788	$799,857
1893	$5,040	$158,116
1894	$21,730	$712,783
1895	$40,555	$1,362,96
1896	$205,924	$6,920,640
1897	$253,388	$8,621,715
1898	$418,155	$14,228,035
1899	$297,616	$10,126,606
1900	$107,030	$3,641,775
1901	$158,915	$5,340,774
1902	$138,356	$4,538,325
1903	$45,155	$1,448,173
1904	$41,400	$1,312,361
1905	$15,000	$481,067
1906	$176,142	$5,525,990
1907	$78,595	$2,360,153
1908	$12,050	$369,560
1909	$20,800	$645,146
1910	$1,250	$37,129
1911	$4,510	$133,961
1912	$10,548	$306,977
1913	$1,625	$46,306
1914	$190,303	$5,372,613
1915	$2,650	$74,430
1916	$5,700	$146,553
1917	$23,000	$490,798
1918	$105	$1,907
1919	$26,638	$421,229
1921	$50,680	$691,835
1922	$23,350	$380,905
1923	$1,004	$16,090
1924	$22	$351
	$2,427,312	$76,105,492

John McNeill Whistler's portrait, *The Little Note in Yellow and Gold*, 1886, in the Veronese Room

INDEX

PHOTOGRAPHY CREDITS

This publication is made possible
with the generous support of
the Arthur F. and Alice E. Adams
Charitable Foundation.

**ISABELLA
STEWART GARDNER
MUSEUM**

Published by the Isabella Stewart Gardner Museum
25 Evans Way, Boston, MA 02115

Distributed by Princeton University Press
41 William Street, Princeton, NJ 08540-5237
99 Banbury Road, Oxford OX2 6JX
press.princeton.edu

ISBN 978-0-691-23596-7

Library of Congress Control Number: 2022939290
British Library Cataloging-in-Publication Data is available

Designed by Julia Ma, Miko McGinty Inc.
Typeset by Tina Henderson in Faune, Odile, and Mallory
Copy edited by Livia Tenzer
Printed in Florence by Conti Tipocolor

Isabella Stewart Gardner Museum Publications
Elizabeth Reluga

Cover illustrations: (*front*) John Singer Sargent, *Isabella Stewart Gardner*,
1888; (*back*) Nasturtium display in the Courtyard

The Isabella Stewart Gardner Museum resides on the homelands
of the Massachusett Tribe, who belong to this place and continue to regard
these lands and waters as sacred.

1 3 5 7 9 10 8 6 4 2